IMAGES
of America

TACOMA'S
STADIUM DISTRICT

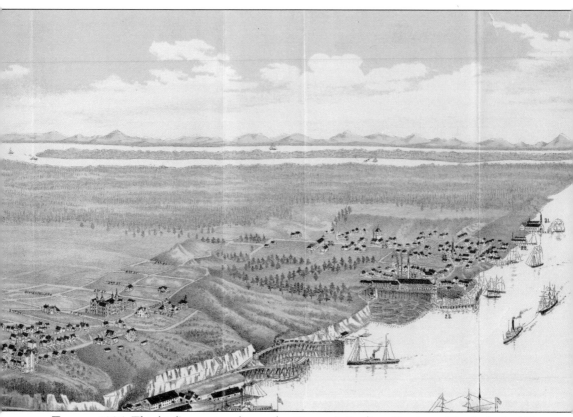

TACOMA 1884. This bird's-eye view shows what Tacoma's Stadium-Seminary District looked like in 1884. Wright Park is located across Division Avenue from Annie Wright Seminary, which in turn was across the street from the original location of the Tacoma Lawn Tennis Club. Stadium Bowl was still a gulch, as was the current location of Annie Wright Seminary. Stadium High School was not yet built, and its future location was a bramble of brush, having recently been clear-cut. This book is a pictorial story of the history of Tacoma's Stadium District. (Courtesy of WSHS-1928.68.2.23.2.)

ON THE COVER: Tacoma's Stadium Bowl is one of the most important historic public places in the region. Stadium Bowl was dedicated on June 10, 1910; however, the catalyst for change began in 1873, which was when Northern Pacific Railroad decided to locate its western terminus in Tacoma. The district received its name after the gulch next to Tacoma High School, which was transformed into one of the nation's first natural stadiums. Located on the bluffs high above Commencement Bay overlooking magnificent Mount Tahoma (Rainier) and next to the spires of the "Brown Castle," Tacoma's Stadium Bowl is truly a special gathering place that has inspired millions. (Courtesy of WSHS-1943.42.32708.)

IMAGES
of America

TACOMA'S
STADIUM DISTRICT

Joy Keniston-Longrie,
Kelsey Longrie, and Amberose Longrie
Foreword by Bill Baarsma

ARCADIA
PUBLISHING

Published by Arcadia Publishing
Charleston, South Carolina

Printed in the United States of America

Library of Congress Control Number: 2009943325

For all general information contact Arcadia Publishing at:
Telephone 843-853-2070
Fax 843-853-0044
E-mail sales@arcadiapublishing.com
For customer service and orders:
Toll-Free 1-888-313-2665

Visit us on the Internet at www.arcadiapublishing.com

Dedicated to past, current, and future students, residents, and visitors who live, study, work, visit, and play in Tacoma's Historic Stadium District.

CONTENTS

ACKNOWLEDGMENTS

Special thanks goes to the following: former mayor Bill Baarsma; Brian Kamens; Jeanie Fisher; Jody Gripp; Bob Schuler, Tacoma Public Library; Judy Wright; Amber Santiago; Brandon Reynon; Sheryl Melius, Puyallup tribe; Joy Werlink; Elaine Miller; Fred Poyner, Washington State Historical Society; Jon Kellet, former SHS principal; Gail Barnum, current SHS principal; J. Drashil, SHS photography teacher; Bob Baumgras, SHS facilities; Mary Bowlby, Job Carr Museum and Tacoma Historical Society; Kathleen Barr Smith; SHS class of 2010 seniors—Dylan Dimico, Bailey Carr, and Katie Ryesmus—who gave their opinions and input to make history; Marc Blau; Sherif J. Awad, CFP®, Raymond James Financial; Ron Karabaich, Old Town Photo; Caroline Denyer Gallacci; Deanna Rankos; and Sarah Higginbotham and Devon Weston, editors at Arcadia Publishing. Last, but certainly not least, a special thank you to our family: Mark Longrie, Robert and Joan Weaver; Eleanor Farr; Tom, Dick, and Joanne Sisul; Darrol and Judy Smith; Kathleen Barr Smith; and Lorraine Keniston.

The following abbreviations have been used in this book:

NPRR: Northern Pacific Railroad
MOHAI: Museum of History and Industry
SHS: Stadium High School
SPL: Seattle Public Library
TDL: *Tacoma Daily Ledger*
TLTC: Tacoma Lawn Tennis Club
TPL: Tacoma Public Library
USLOC: United States Library of Congress
UWSC: University of Washington Special Collections
WSA: Washington State Archives
WSHS: Washington State Historical Society
WSU-MASC: Washington State University-Manuscripts, Archives, and Special Collections

Approximations of current equivalents for historic dollar amounts on pages 26, 56, 64, and 65 were calculated using the Consumer Price Index method on www.measuringworth.com.

FOREWORD

A high school that was originally planned to be the "grandest of all grand hotels," a church that reminds one of the Sant' Ambrogio in Milan, and a 27-acre arboretum that is known as Wright Park are all in one remarkable neighborhood, the Stadium District. But my memories rest on its iconic centerpiece—the Stadium Bowl, which marks its centennial in 2010.

It started as a rumble, leading to a roar, and then what sounded like an explosion. I thought the old sawdust-fed boiler in the basement of Lowell Elementary School, which was where I was a first grader, had blown up. But it was actually the great earthquake of April 13, 1949. The earthquake did serious damage to our city, including the subsequent condemnation and closure of Stadium Bowl.

The Bowl was truly Tacoma's central gathering place and an engineering marvel. Its closure was as much a blow to the community as the failure of the first Narrows Bridge, known as Galloping Gertie, and the demise of the incredibly impressive Tacoma Hotel by a mysterious fire. There was simply nothing like the Bowl's grandeur with its great site lines and views of Puget Sound. Three U.S. presidents spoke there; Babe Ruth, legend has it, hit a baseball into Commencement Bay from the floor of the Bowl; and the Washington State Cougar football team played nationally ranked Texas A&M to a standstill in a game before 35,000 fans. One year an estimated 70,000 people gathered there for a Fourth of July celebration. Trolley lines were built and extended to transport people to the events.

That was my early recollection of the Stadium District. It was all about the Bowl and later, its reclamation. During my years at Stadium High School, I made many other memories. Some include the following: visiting the Ferry Museum, hanging out at Ranko's Pharmacy waiting for the Point Defiance bus, having a burger and shake at Scotties (now the Harvester restaurant), and shooting hoops at Wright Park.

The Stadium Bowl with the truly extraordinary high school standing above it, the park, views, museums, architecture, plus the long-standing businesses and mixed-use residential neighborhoods of this remarkable district are all part of what put Tacoma on the map. The historic legacy of the Stadium District, in many respects, defines why Tacoma became known as the "City of Destiny."

—Bill Baarsma, Stadium High School class of 1960
Mayor of Tacoma, 2001–2009

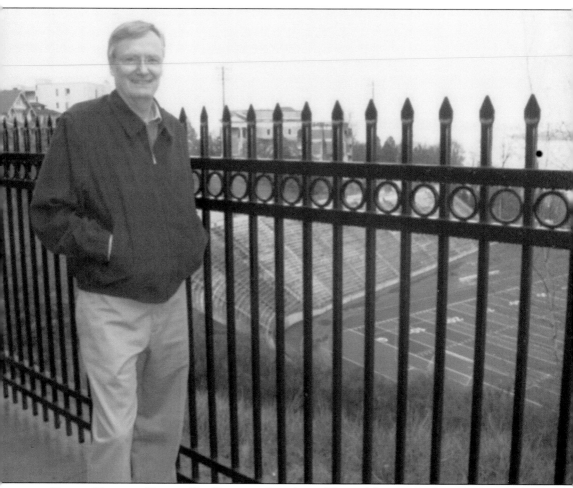

FORMER MAYOR OF TACOMA BILL BAARSMA. Standing at Tacoma's historic Stadium Bowl overlooking beautiful Commencement Bay, Tacobet (Mount Rainier), and the Washington State Historical Museum, Bill Baarsma, member of Stadium High School class of 1960, enjoys the view and looks forward to the Centennial Celebration of Stadium Bowl in 2010. Baarsma became the first Tacoman to be awarded the "Scottish Rite Freemasonry Fellowship" for graduate studies at George Washington University in Washington, D.C., in 1964, where he earned his master's degree in government and his doctorate in public administration. A sports enthusiast, he has dedicated his life to the betterment of Tacoma, its students, visitors, and residents. (Courtesy of Mayor Bill Baarsma.)

INTRODUCTION

When Commencement Bay was selected as the western terminus for the Northern Pacific Railroad (NPRR), the area we know as Tacoma's Stadium District was an old-growth temperate rainforest, interspersed with wetlands, creeks, streams, and gulches. Access was primarily from the saltwater shorelines by way of a narrow footpath, called Beach Trail, which led from the shore along the high bluff overlooking Puget Sound and Mount Tahoma. The old growth forests have long since been transformed into one of the most historically significant places in Tacoma, and the location remains a vibrant place to live, work, study, and play.

This book uses historical images to depict the significant environmental, landscape, social, and economic changes that the decision to locate the NPRR terminus here brought to this special place. To bring the story to life, the authors have tried to go beyond the beautiful structures to give a glimpse inside the homes and share the stories of the people who lived here. Tacoma's Stadium District was home to many of the most influential people of the century, who shaped the city, state, region, and the world via the export of timber, lumber, wheat, coal, and other natural resources. Tacoma's Stadium Bowl, Stadium High School, parks, and residential areas have inspired and empowered multiple generations to reach for goals others may think impossible to achieve.

While there are specific boundaries associated with the historic district, the authors use geographic landmarks to denote the area as follows: East is Commencement Bay; North is North Tenth Street; South is South Seventh Street; and West is I Street. Due to the abundance of historical images, the authors direct readers to other Arcadia Publishing titles to further enrich the story in these pages—*Wright Park, Downtown Tacoma, Old Town, Proctor District, Woodbrook Hunt Club, Tacoma's Waterfront,* and *Seattle's Pioneer Square*. The authors hope that this book will help current and future residents and visitors cherish the historical events, buildings, people, views, and locations associated with this uniquely beautiful place in the world, Tacoma's Stadium District.

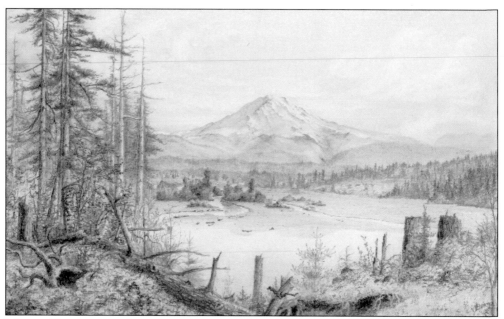

MOUNT TAHOMA AND PUYALLUP VILLAGE. This 1876 watercolor (above) of Mount Tahoma and the Whulge (Commencement Bay) was painted by W. Beaven from the vantage point on the bluff where Stadium High School is located today. The Puyallup River's two channels and deltas were in their natural form. Logging of the trees along "Stadium" bluff was just beginning. Below, c. 1870, small S'Puyalupsh (Puyallup) villages were interspersed along the shoreline of the Whulge from today's Union Station to Point Defiance. Old growth forests along the banks can be seen in the background. Mount Tahoma (Rainier) has played an integral part in the First Peoples' lives, and as we carry on our daily lives, we are privileged to live in the shadow of this magnificent mountain, which is a Pacific Northwest icon. (Above courtesy of Roger Cushman Edwards, below courtesy of WSHS 1996.14.2.)

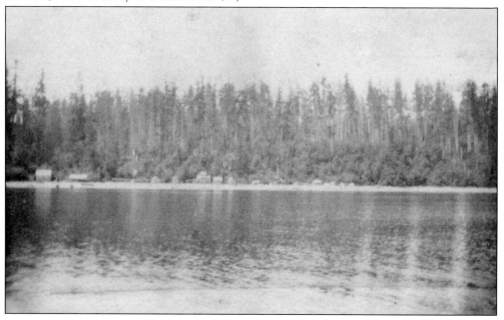

One

CHE-BAU-LIP

The First Peoples who lived here called themselves S'Puyalupabsh, meaning "generous and welcoming to all people (friends and strangers) who enter [their] lands." Today they call themselves the Puyallup tribe. The S'Puyalupabsh are closely associated with the Squally-bausch, the Nisqually tribe, whose name means "people of the grass country and people of the river." The First Peoples utilized the shoreline's bountiful resources. Both tribes are part of the Salish-speaking people of the Pacific Northwest. Their dialect is the "Twulshootseed," which is shared with a number of other tribes including the Duwamish, Suquamish, Squaxin, and others. The S'Puyalupabsh people lived in villages from the foothills of Tacobet along rivers and creeks to the shores of the Whulge (the Salish name for Puget Sound). Tacobet played a significant role in the daily and spiritual life of the S'Puyalupabsh. The Whulge was important for transportation, socializing, and sustenance. It provided an abundance of natural resources for food, including salmon, shellfish, and waterfowl. The heavily forested uplands provided wildlife, roots, and berries to complement the aquatic food sources, as well as materials for transportation and shelter.

The S'Puyalupabsh called this area Che-bau-lip (a protected harbor) in Twulshootseed. The geographic center was marked by an 8-foot-tall "signal rock," the Che-bau-lip Rock, on which were carved many Native American inscriptions. This significant landmark served as a meeting place for all chiefs from many miles around and was located on the beach behind the old NPRR headquarters. Che-bau-lip extended geographically to the natural inlet just south of today's Old Town, where Garfield Gulch meets the shoreline. The S'Puyalupabsh depended on annual salmon runs and made seasonal fishing camps at special areas. The shoreline and gulch located immediately below the Stadium District was called Hud-Hud-Gus (a camping place, or place of many fires). The protected lagoon south of Old Town was also a seasonal fishing camp. Many tribes used both of these areas for extended periods during salmon runs. The hillsides and cliffs held special sacred meaning for the S'Puyalupabsh as they made their journey to the spirit world.

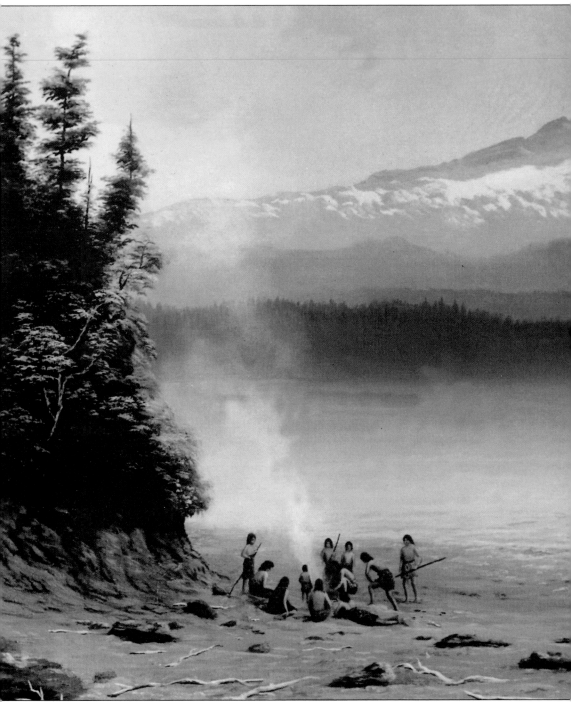

TACOBET. John (Xot) Hote, Puyallup tribal signer of the 1854 Medicine Creek Treaty, recalled that from time immemorial "Tacobet fed the Puyallups and her grandchildren, the Yakamas, through her rivers, the Puyallup and the Yakama, which she kept always supplied with life-giving fish and clear cold water." Tacobet had received this privilege from Guilbitch (the moon) according to the stories that Hote's forefathers told about the campfire. "In the beginning of things, Tacobet

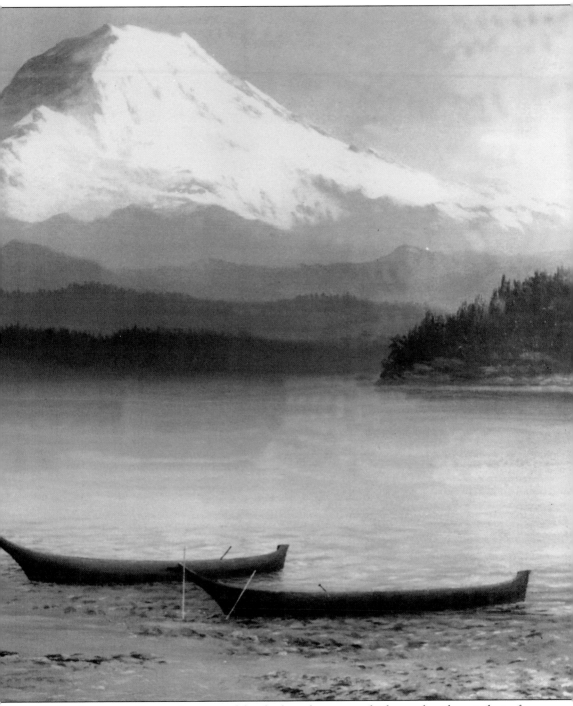

was a lovely woman. She was less powerful only than the moon, which gave her the privilege of choosing what she would like to be when the end came. She wished to be a mountain, she said, because in this way she might always feed her grandchildren, sending everlasting life to her own people, the Puyallups." Today, Tacobet is known as Mount Tahoma or Mount Rainier. (Courtesy of UWSC-BAR300.)

Temperate Rain Forests. The tall pi-yats (cedar trees) grew profusely along the shores of the Whulge and provided habitat for many animals and birds. The old-growth temperate rainforests had a variety of tree species, including kla-ka-bupt (hemlock), kwank-sa-bupt (alder), pi-yats (cedar), and the most prolific, Douglas fir. Skeg witts (deer), bear, and cougar supplemented the S'Puyalupabsh fish diet. Skwa lat lude (berries), roots, and other medicinal plants were also gathered and utilized. (Courtesy of WSHS-1943.42.58345.)

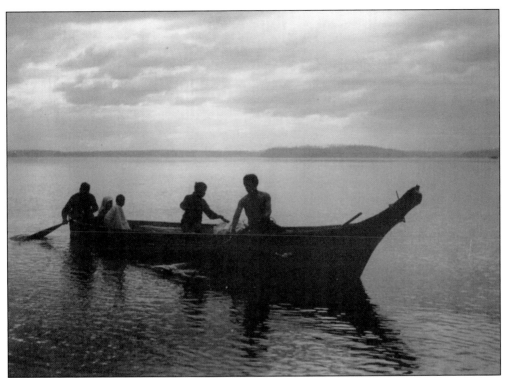

KE'LO-BIT (CANOES). After a tall pi-yats was blessed, it was cut down, the center burned out, and the interior and exterior of the log carved and rubbed smooth. Ke'lo-bit were made in a variety of styles with seating capacity ranging from two to thirty people. Canoes also provided a means for fishing and gathering shellfish. (Courtesy of TPL.)

NATIVE VILLAGE. Seasonal S'Puyalupabsh villages were located along the shores of the Whulge and at the inlet where Garfield Gulch daylights to the shore. Pi-yats provided the primary shelter, called a'-lal (longhouses). A'-lal were used by several families in the winter time. This scene shows cedar homes, canoes, and fish-drying facilities along the Whulge. (Courtesy of TPL.)

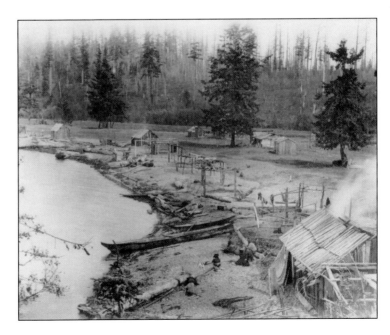

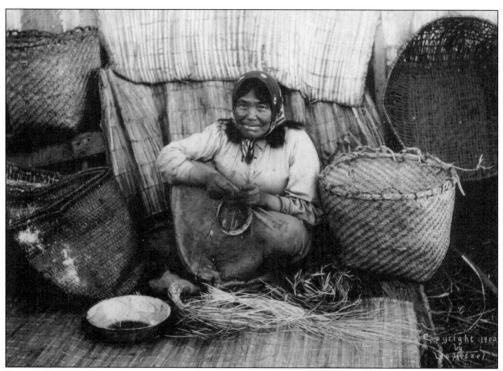

Sı-ᴀʟᴛ (Baskets). This S'Puyalupabsh woman is weaving a si-alt, which is an art passed from generation to generation. Weavers specialized in their own unique repetitive patterns through contrasting colors of bark or grass, which often depicted animals or other natural features. They were made in all sizes and were used for cooking, storing, and hauling food, water, and other objects. (Courtesy of UWSC-SOC0884.)

Gathering Shellfish. When the tide went out, "the table was set;" beaches provided ample shellfish for gathering, eating, and drying. This woman is using a stick to help gather shellfish, which she carries and stores in her basket. Shellfish of all types, which included a qu (clams), cloth cloth (oysters), geoducks, and mussels, were common in the S'Puyalupabsh diet. They were eaten fresh, cooked, and smoked to preserve for later use. (Courtesy of USLOC-LC-USZ62-99363.)

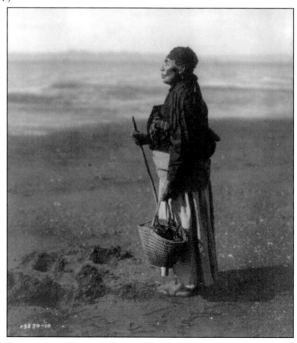

ABUNDANT SLEYCAALLCUB (WILD FOWL). Extensive tidelands existed where the Puyallup River emptied into the Whulge, which provided an abundance of habitat for aquatic life and birds. Old-timers said millions of birds flocked to the tide flats for food, rest, shelter, and breeding. Birds chased herring-balls for food and signaled fisherman. The S'Puyalupsh set duck traps, and duck, or squalich, supplemented their rich healthy diet. (Courtesy of UWSC-Oceanography-30.)

FISHING WEIR. Sqawak wee (salmon) was the mainstay of the S'Puyalupsh and other Puget Sound tribes' diet. In addition to fishing from canoes, fishing platforms made from trees in a tripod shape were also used to catch fish. The platform was set in the Sto Luck (Puyallup River), and tree branches were used to form a fence, which then funneled the fish into a more narrow area where they were caught. (Courtesy of UWSC-NA418.)

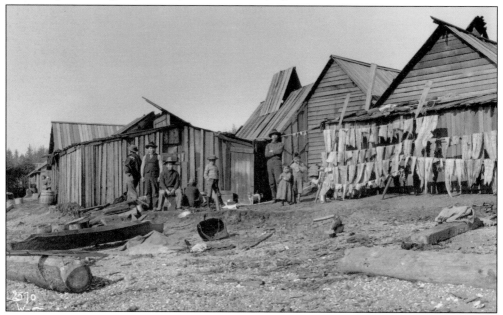

DRYING FISH. Sqawak wee runs came in cycles and in large quantities. In order to ensure food throughout the year, the S'Puyalupsh preserved sqawak wee through drying and smoking methods. Hud-hud-gus and Che-bau-lip villages had to clean and dry salmon to store in si-alt for the winter. Here sqawak wee is shown drying on a rack near cedar plank houses. These Native Americans are dressed in western-style clothes. (Courtesy of MOHAI-83.10.6.950.)

A'-LAL. Pi-yats were cut and split into planks to make a'-lal, which were sometimes 50 feet long by 40 feet wide or bigger. A longhouse provided permanent shelter for several extended families. Fires were kept burning, so it was often smoky inside. There were plank benches along the interior edges. A permanent village usually had several longhouses. (Right courtesy of Whitman College, below courtesy of WSA-Native American Longhouse.)

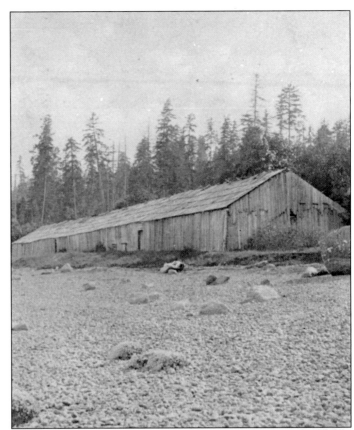

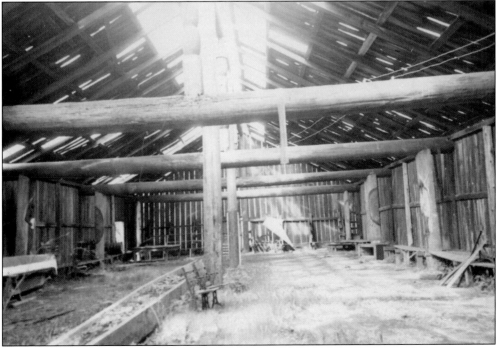

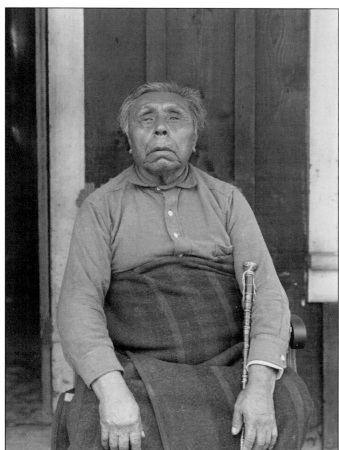

JOHN HOTE. The 1854 Medicine Creek Treaty was signed by several tribes. John Hote signed for the S'Puyalupsh tribe. The signing took place by a large tree located on the Nisqually Flats. Chief Leschi from the Squally-bausch tribe refused to sign the treaty due to dissatisfaction of the proposed size and location of treaty lands. It is doubtful whether the signatory tribes fully understood the treaty's implications for their people. (Courtesy of WSHS-Boland-GI484.)

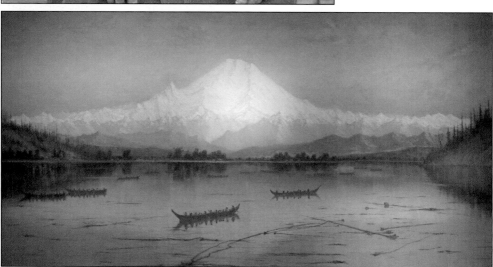

SUNSET. The setting sun cast its last calming pink and purple rays on canoes swaying in kelp-beds of the Whulge under the shadow of Tacobet. This painting reflects no hint of the turmoil and change that was about to descend upon this tranquil setting and the S'Puyalupabsh tribe. (Courtesy of WSHS-1999.63.295.)

Two

THE IRON HORSE

The dream for a cross-continental railroad had been envisioned for decades. Every town along the shores of Puget Sound competed intensely to be the chosen site for the western terminus.

On July 14, 1873, R. D. Rice and J. C. Ainsworth, commissioners of the Northern Pacific Railroad, sent a telegram stating, "we have located terminus on Commencement Bay." It was sent to Arthur Denny in Seattle's Pioneer Square and to General McCarver in Tacoma City. The news brought jubilation in Tacoma City. Significant consternation and disappointment characterized sentiments throughout the remaining Puget Sound towns. When Denny read the telegram to the anticipatory crowd gathered in Seattle's Pioneer Square, the news was received with shock, disbelief, and anger. It created tremendous animosity, which has permeated through many generations, from Seattle's residents towards Tacoma. Meanwhile, 35 miles to the south, McCarver was ecstatic with joy—until he discovered the NPRR terminus was located 2 miles to the south at New Tacoma. The chilling effect was that none of the Puget Sound pioneers, many of whom had labored for decades to attain the crowning glory of the western terminal location, received direct benefit from the decision. Local lore has left the impression that many lost considerably large amounts, both economically and personally. The immediate direct benefits went to a handful of eastern tycoons associated with the NPRR subsidiary, Tacoma Land Company. But in the long term, local old-Tacomans did benefit.

In 1873, Tacoma had a population of approximately 100 non-native people (compared to Seattle's 1,800). Virgin shores and old-growth forests reigned under the shadows of mighty Mount Tahoma. The interior uplands were impenetrable forests entangled with thickets, enormous standing and fallen trees, swamps, wetlands, streams, rivers, and huge gulches, which provided a habitat for many upland creatures. Teeming with fish, aquatic mammals, and waterfowl, the aquatic lands were dominated by Puget Sound's salt water, including vast tidelands at the headwaters of Commencement Bay. The shorelines were dotted with villages occupied by the Puyallup tribe, and burial grounds. Dramatic landscape, environmental, social, and economic changes were triggered by the seven-word telegram. Tacoma's early progress was shaped by regional politics, economics, and egos. Key support came from eastern leaders including Charles B. Wright, and opposition came from Henry Villard in Portland, and from Seattle's Pioneer Square.

PRESS 1873. The decision to locate the NPRR's western terminus on Commencement Bay was not popular. Only one out of four major Puget Sound newspapers supported the decision. Within the first week, seven Seattle leaders including Henry Yesler and Arthur Denny with "their lofty beavers glistening in the noontide sun," as the *Puget Sound Express* described them, traveled to Steilacoom on the Zephyr to appeal the decision. By August 1873, litigation was filed in Congress. The press described New Tacoma as a "town of sawdust and fleas." (Both courtesy of TPL.)

PUGET SOUND EXPRESS.

STEILACOOM, W. T., JULY 1, 1873.

THE TERMINUS.

For years the public mind has been on the *qui vive* as to the point that might be selected by the Northern Pacific Railroad Company for the final terminus on Puget Sound of the great highway of the commerce that their road across the continent establishes. Many points on the Sound have struggled and presented to the agents of this company their best showing and offers for the terminus. This was proper. The agents of the company have doubtlessly respectfully and *fully* considered the several propositions, and the western terminus of the North Pacific Railroad is now an established fact. History might properly record, and will when written, that Tacoma, in Pierce County, is the great city of the Northwest—made so by the honest action of men of integrity and unquestioned character, who had been entrusted by the leading financial minds of the country with the power to settle this great and vital question.

Many of the papers on Puget Sound, in their way, are making feeble efforts to "throw cold water" on and retard the progress of manifest destiny. To them we say, you are in error. The particular locality and small surroundings of your homes, and the biased, dwarfed and interested opinions of the multitude from

RAILROAD PROJECTS.

Railroads and railroad projects seem to engross every mind at the present time, but the American people in particular have acquired such a mania for this class of excitement that nothing else seems to satisfy or divert their attention. Even our friend Mr. Brown, of the Seattle *Dispatch*, whom we most profoundly respect for his old age and sometimes wisdom, has succeeded of late in building on paper some three or four branch roads to various points on this side of the Rocky Mountains, and if he is spared to the public a few weeks more, there will not be a town or hamlet in Washington Territory that will not have one or more switches.

Olympia, too, wants a switch, cannot live without one, and in time may get a narrow gauge, but not until she increases in wealth and population. Her hopes are now centered on a coal mine, in embryo, on Skookum Chuck, but whether or not she will succeed in delving into the bowels of the earth far enough to raise a merchantable article is a question yet to be answered. But suppose she does. Where is then the shipping point—at Olympia or Budd's Inlet?

Balch's passage is a great obstruction to navigation, and owners of vessels cannot afford to lose a week in transit from Steilacoom to Olympia. This being the case, capitalists will not invest their money until they find a proper outlet and shipping point for the coal, and, unless

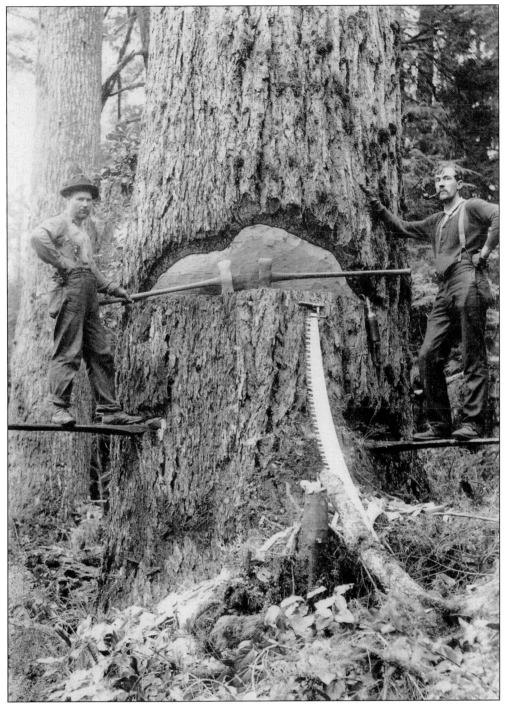

LOGGING. The Delin and Judson families began logging in the 1850s; however, the announcement of the terminus location in Tacoma catalyzed speculators to begin buying land, cutting the enormous old growth timber, and clearing the land. The tree trunks were so large that spring boards were inserted for the loggers to stand on while using their whip-saws and axes to bring the giant trees down. (Courtesy of TPL.)

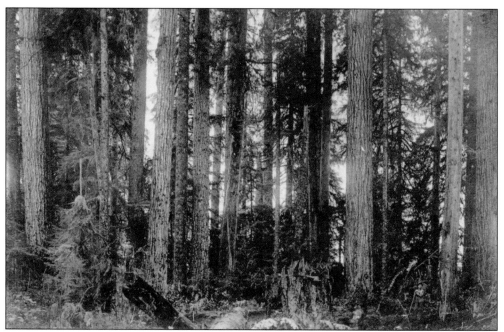

OLD GROWTH. With time the old growth forests that provided habitat for a wide variety of animals as well as food, shelter, and clothing for the Puyallup people began to disappear. Cedar, hemlock, and Douglas fir—each standing nearly 300 feet tall, measuring up to 18 feet in diameter, and some over 600 years old—fell to the logger's ax and made their way to the market. (Courtesy of TPL.)

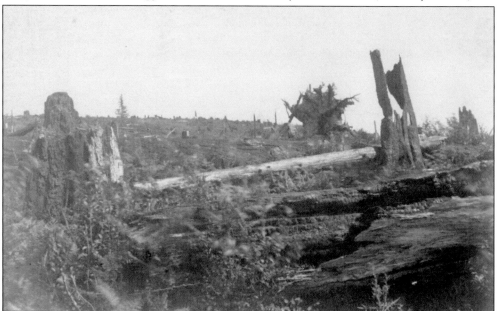

CLEAR CUTS. Once the trees were cut, logs were skidded to a local sawmill. The remaining limbs and branches were piled as slash and burned. Removing large old growth stumps proved to be more of a challenge, which usually required several sticks of dynamite. The visual landscape changed dramatically as a result of clear cuts in preparation for the projected population growth of New Tacoma. (Courtesy of WSHS-2010.0.282.)

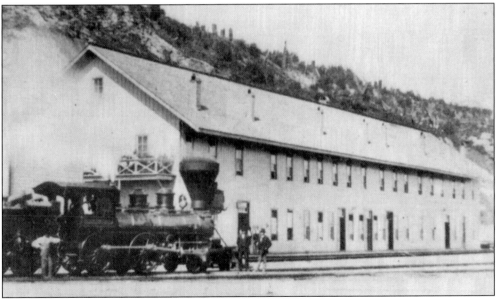

NORTHERN PACIFIC RAILWAY

A. D. CHARLTON
A. G. P. A.
PORTLAND,
ORE.

The North Coast Limited

A. TINLING
GENERAL AGENT
925 PACIFIC AVE.
TACOMA,
WASH.

IRON HORSE. Gen. Morton McCarver, Gen. John Sprague, and Job Carr each took a turn at the sledge to drive the last spike of the railroad track on December 16, 1873. The first train passengers to Tacoma were William and Alice Blackwell and their daughters Ruby and Ethel, who were 7 and 12 years old respectively. Furniture for the new Blackwell Hotel was the first cargo transported by rail to Tacoma. (Courtesy of TPL.)

BLACKWELL HOTEL. Opened on January 1, 1874, the Blackwell Hotel was located on the NPRR wharf on the shoreline, on the second floor of this building. NPRR offices occupied the first floor. The hotel had a capacity of 100 guests. Kept "clean as a pin," there were 60 beds, a bar, and restaurant. Herbert Hunt writes, "The waterway was alive with fish; game birds came to the tide flats by the thousands; forests teamed with deer. The Blackwell Hotel set a table renowned throughout the northwest." (Courtesy of TPL.)

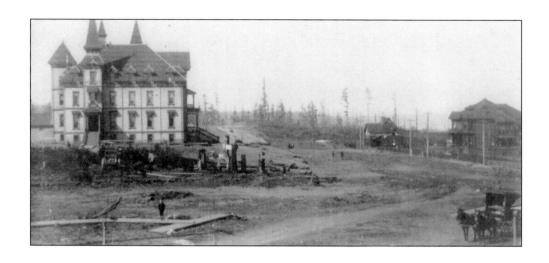

ANNIE WRIGHT. Recognizing the importance of establishing educational opportunities equal to or surpassing those of the East Coast, Charles B. Wright, NPRR president, established a $50,000 endowment for a private girls' seminary, approximately $1 million today. Per the Freemason tradition, Bishop Paddock laid the cornerstone in 1883. Annie Wright, the school's namesake, placed a time capsule in the cornerstone with the aid of her father, who guided the stone into position. Annie Wright Seminary, located on the triangular parcel between First Street and Division Avenue, opened in 1884 with 46 students. The photograph above was taken from Wright Park. Division Avenue is in the foreground and Tacoma Avenue can be seen to the right of the school. Streets are dirt and the forest edge can be seen at approximately Second Street. When Tacoma Avenue was extended to connect with Old Town, it was initially a toll road; the funds collected were used to offset the construction costs. Even with tolls, it was a heavily used road. Shown below, the school's main entrance faced Tacoma Avenue. (Both courtesy of TPL.)

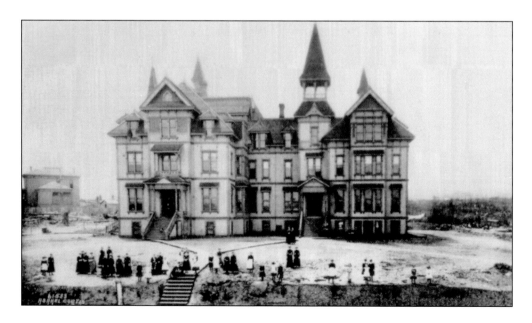

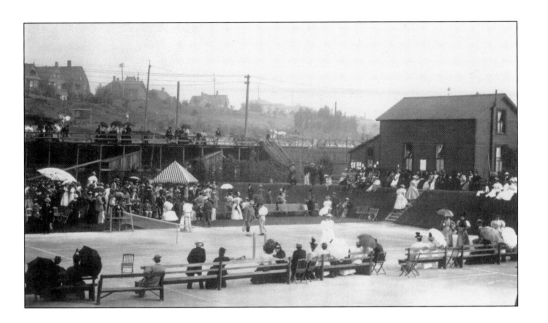

ANNIE WRIGHT SEMINARY, LAWN TENNIS CLUB, AND WRIGHT PARK. Gradually the streets were improved, and wooden sidewalks were added to the landscape around Annie Wright Seminary, which was designed by W. E. Boone, a direct descendant of Daniel Boone, and Meeker Architects. The image above is looking south from the original Tacoma Lawn Tennis Club towards Wright Park with homes along South G Street visible. The image below was taken looking north from Wright Park with Annie Wright Seminary in the background. Wright Park had been clear-cut. The natural wetland had been converted to a pond, and the statue donated by Clinton Ferry had been added. Elegant homes that had sprung up along South G Street can be seen. Sadly, most of the homes are now gone; however, the pathways from the residential areas into the park still exist today. (Above courtesy of TLTC, below courtesy of TPL.)

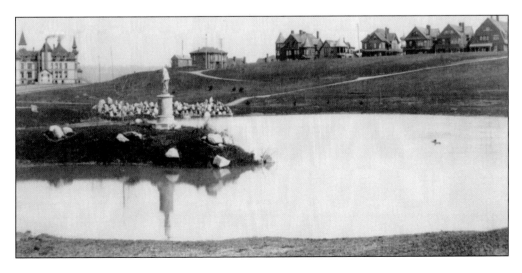

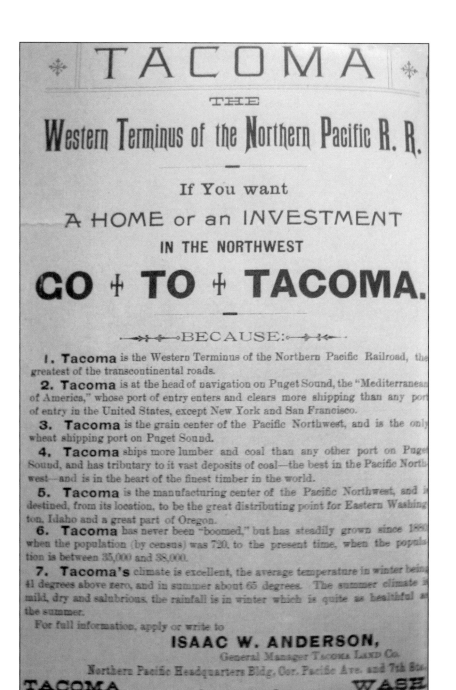

LAND! MONEY! OPPORTUNITY! The Northern Pacific Railroad ran national advertisements to entice people to move west. Beginning in the 1870s the NPRR developed extensive booklets explaining the opportunities and advantages. These booklets included detailed explanations on the beauty and bounty of Tacoma. Instructions on how to save money associated with logging and clearing land for residential and commercial enterprises were listed as well. This advertisement expounded on the wonderful natural benefits of Tacoma and Commencement Bay. By the 1890s, Allen C. Mason was spending $10,000 per year advertising Tacoma in eastern newspapers. The Tacoma Land Company also ran an extensive advertising campaign. (Courtesy of TPL-Polk-1890.)

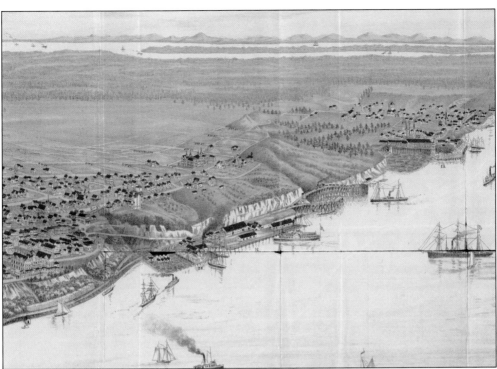

1885 Bird's-Eye View. Above, the idealized 1885 birds-eye view of Tacoma is focused on the area the Puyallups called Che-bau-lip and Hud-Hud-gus; today it is known as Tacoma's Stadium-Seminary District. Beginning in 1873, this area was transformed into the NPRR wharf complex along the shorelines and later into Tacoma's most influential residential area, high on the bluffs above the NPRR wharfs and Blackwell Hotel. To the north, coal bunkers can be seen at the gulch opening onto the natural beach. To the far right, the Ackerson Sawmill can be seen at the bottom of Garfield Gulch. High on the bluff, Annie Wright Seminary can be seen (below), as well as the beginnings of a prestigious neighborhood. The size and style of these 1885 mansions foretell the area's future legacy, including Edward Huggins's towered home on the gulch (page 37). (Both courtesy of WSHS 1928.68.2.23.2.)

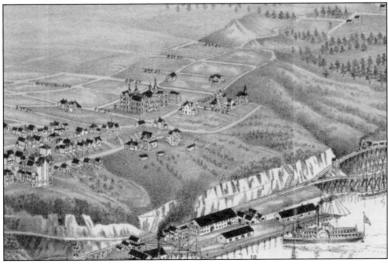

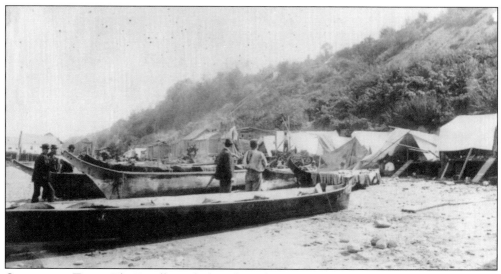

CANOES AND TENTS. The Puyallup tribe has always been a part of Tacoma's history. The arrival of the iron horse resulted in significant interaction between the Puyallup and the newly transplanted settlers, creating a transitional historical period that blended cultures on the shorelines below the bluffs of today's Stadium District. The beaches provided a natural landing place for canoes, ke'lo-bit, as well as a sheltered place for permanent and temporary housing prior to and during industrialization. (Courtesy of TPL.)

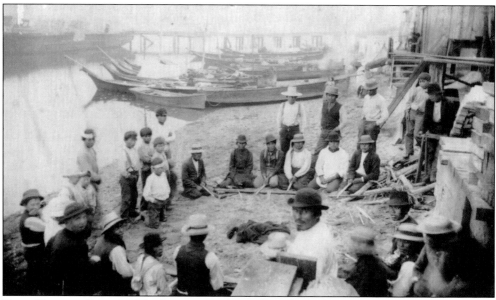

BONE GAME, OR SLA-HAL. The Bureau of Indian Affairs focused on the elimination of traditional Native American culture. However, traditional games were common sights along the shores of the Whulge from the 1870s to the 1910s. The bone game, sla-hal, involves two teams sitting opposite each other. Three white bones and one painted bone are passed among team players, and the objective is to guess the location of the painted bone. Singing and chanting are used to distract the opposite team. (Courtesy of TPL.)

Three

HOME SWEET HOME

As Tacoma's population grew—100 people in 1873; 760 by 1880; 30,000 in 1890; and 50,000 in 1898—the people streaming into town needed places to live. With the clearing of land, the building boom escalated, especially between 1887 and 1893. Houses were being built in all directions from downtown Tacoma. The tycoons, industrialists, capitalists, and many laborers made the area near the original Annie Wright Seminary, now known as Tacoma's Stadium District, their home.

The initial nucleus of power and prestige concentrated along C Street (now called Broadway) and gradually moved north of Division Avenue from Cliff Avenue (now Stadium Way) and along North C, D, E, G, and I Streets and Yakima Avenue. Murray Morgan writes, "The houses were large, comfortable, and always with a view of salt water and snow-capped mountains. The residents vied with each other in the handsomeness of their carriages and the sheen of their horses." It was not coincidental that some of the earliest modern conveniences, steam-powered streetcars, gas, electricity, water, sewers, and paved streets, first appeared in this area. Around this prestigious neighborhood were wonderful amenities, beautiful Wright Park, churches of all denominations, and hospitals endowed by local residents, that made it such a splendid place to live. High-density housing has long been a part of this neighborhood's urban landscape. Local businesses and schools were conveniently located close to the influential neighborhood.

As time passed, many of the influential families (Griggs, Hewitt, Wagner, Weyerhaeuser, Thorne, and so forth) associated with the nucleus of power between Tacoma Avenue, E Street, and Fourth and Fifth Streets relocated permanently to their summer playgrounds on the lakes in Lakewood. Ensuing economic depressions and urban renewal resulted in the loss of many of these historic gems; however, Tacoma Stadium-Seminary Historic District was one of the first in the state and continues to be one of the best preserved and most sought after neighborhoods in the Pacific Northwest in which to live, work, study, shop, and play.

Place names historically associated with Tacoma's Stadium District include the following: Blackwell's Point, Buckley Hill, Mount Ainsworth, Job Carr's Mountain, Ashton's Hill, Garfield Gulch, Che-bau-lip, Hud-Hud-Gus, McCarver's Gulch, and Old Woman's Gulch.

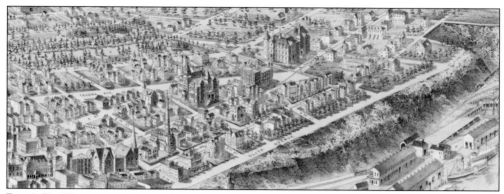

BIRD'S-EYE VIEW, 1890. During the 1880s, C Street (today's Broadway) was the exclusive residential district of the city. The mansions of Tacoma's early aristocracy just north of St. Luke's Episcopal Church belong, from left to right, to Chester Thorne, Isaac Anderson, and John Baker. Pictured on the east side of C Street overlooking Cliff Avenue are the homes of the following people: "Skookum" Smith, Nelson Bennett, William Blackwell, George Kelly, Edmond Rice, Frank Cardin, A. M. Ingersoll, Robert Wingate, Henry Drum, and Walter Thompson. (Courtesy of WSHS-LA-1968.25.1.)

C STREET AND SEA VIEW. As Tacoma's residential area began to grow in the mid-1880s, C Street was soon called "Banker's Row." Elegant Victorian homes sprung up along both sides of the street. All had spectacular views of Puget Sound, Mount Tahoma, and the Olympic and Cascade Mountains. Browns Point, which at the time was part of the Puyallup Indian Reservation, can be seen in this image. (Courtesy of WSHS-2010.0.280.)

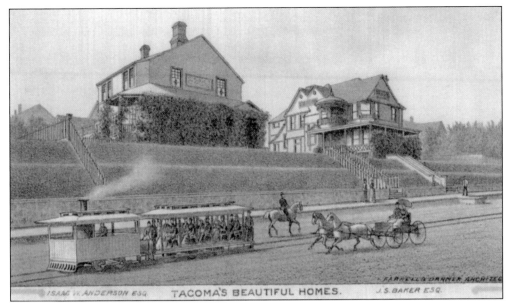

ANDERSON/BAKER. The homes of Esquires Isaac Anderson of 426 C St. and J. S. Baker of 436 C St. are featured in this 1885 illustration. Anderson, NPRR superintendent, arrived in Tacoma in 1877. He organized the streetcar system and served on city council and the park board in the 1880s and 1890s. Anderson established two horse racetracks (Proctor District and Old Tacoma Cemetery) and was the founder of Tacoma's Bicycle Club and Horse Driving Club. Anderson's home became University Club and Tacoma's Women's Club House. John S. Baker, Bank of New Tacoma investor, owned significant property holdings. Baker started Tacoma's first baseball team *c.* 1885. (Courtesy of TPL.)

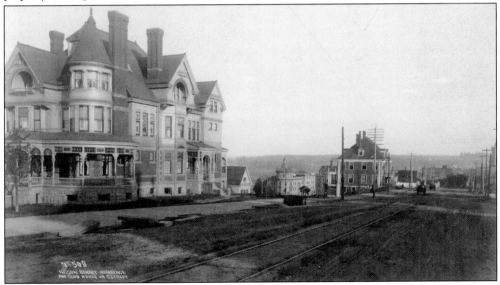

NELSON BENNETT. This gorgeous mansion, built in 1889 at 505 C St., features 26 rooms, exquisite woodwork, and spectacular views. It served as the University Club from 1915 to 1946, when it was demolished. Bennett built Stampede Pass Tunnel (the second longest in the United States), Nelson Bennett Tunnel in Ruston, Tacoma's streetcar system, and founded Tacoma Riding Club. His daughter Nelsie (Mrs. Minot Davis) served as the first woman president of the Woodbrook Hunt Club. (Courtesy of WSHS-2010.0.56.)

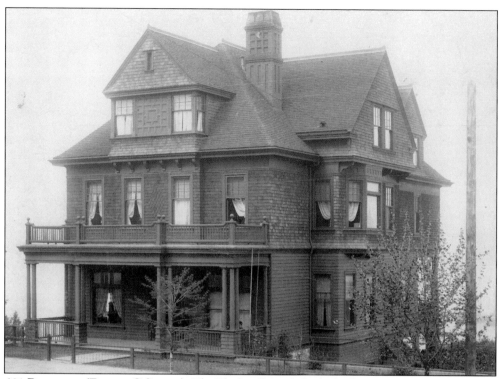

401 BROADWAY (FORMER C STREET). The Blackwell family built this house in 1891. Their original home was purchased by the NPRR to build the Tourist Hotel in 1890 (pages 66–70). Known as the house with three front doors and 100 stairs, it had a beautifully landscaped garden and several elaborate stained-glass windows. The interior (below) was decorated with fashionable Victorian furnishings and boasted a magnificent oak staircase, which was considered the finest in the Pacific Northwest. Broad covered porches opened onto an unparalleled view of Puget Sound. The Blackwells made money in the hotel business but like many others, they lost much in the 1893 national financial crash. William and Alice Blackwell did not have children of their own; however, they adopted two sisters, Ruby and Ethel, while in New York and raised them in Tacoma. William, a 32nd degree mason, helped found the Humane Society. (Above courtesy of WSHS-1979.68.113.4, below courtesy of WSHS-1973.84.3.3.)

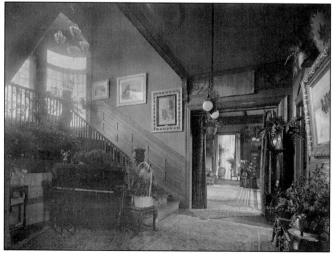

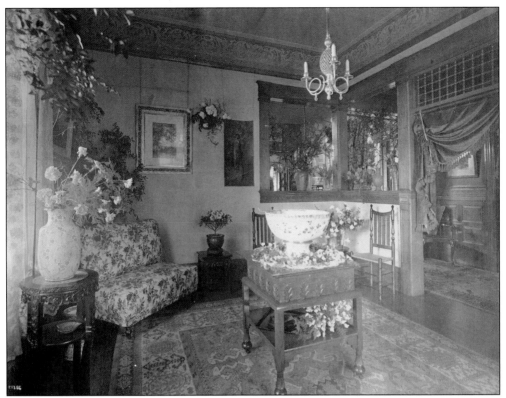

BLACKWELL INTERIOR. The woodwork inside the Blackwell Home was most likely manufactured locally by Wheeler-Osgood Company in Tacoma, which specialized in doors, spindles, and interior wood finishing. The ceilings were 13 feet high, and every room had a fireplace, electrical lights, spectacular oriental rugs, and finishings. Below, William and Alice Blackwell, sitting at the head of the table, celebrated their 60th wedding anniversary (1853–1913) in this home. Today the YWCA occupies the building (page 116). (Both courtesy of WSHS-1973.84.3.2.)

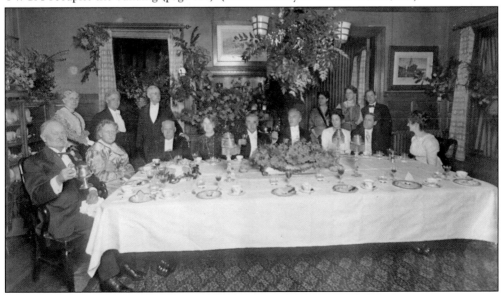

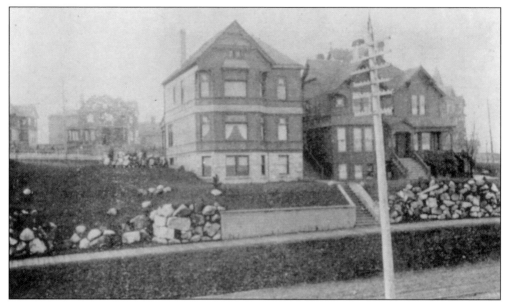

7/9 St. Helens. The original addresses and front doors of the homes of brothers-in-law Henry Drum (left) and Walter J. Thompson were on C Street (today's Broadway), but changed to St. Helens after street re-grading. Thompson's home, built in 1885, and Drum's home, built in 1888, are some of the oldest and most historically significant in Tacoma. Both men were 32nd degree masons. The Drum house was restored by Rasmussen and Hobbs Architecture firm in 1976 as a professional office. (Courtesy of WSHS-2010.0.272.)

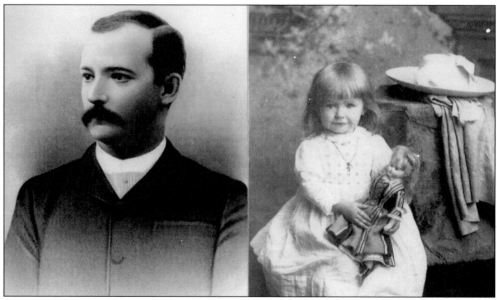

Henry and Laura Drum. A 24-year-old schoolteacher from Illinois, Henry Drum arrived in Tacoma on Christmas Eve 1883. He married Walter Thompson's sister, Jessie, in 1884 in the Thompson Home. At age 29, Henry Drum became the mayor of Tacoma in May 1888. He was the only Democrat elected to the first state senate in 1889. He achieved the royal arch degree in York/Scottish Rite masonry. His two-year-old daughter Laura is posed with a doll. (Left courtesy of TPL, right courtesy of WSHS-2010.0.279.)

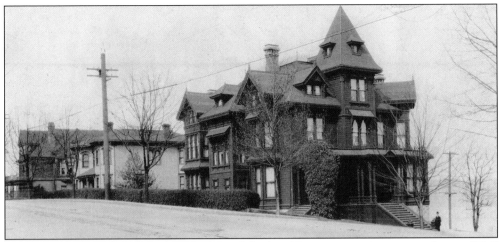

"Skookum" Smith. Edward "Skookum" Smith built a 40-room mansion on seven lots at 423 C St. in 1884; it was considered the finest home in Tacoma. Greatly trusted by Charles B. Wright, Skookum was responsible for the completion of the NPRR Tacoma tracks in 1873 and was involved with the timber and coal industries. This mansion was demolished in 1928 for the Broadmoor Apartments. (Courtesy of WSHS-1979.68.113.1.)

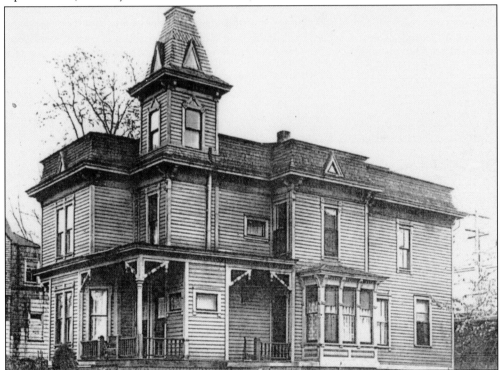

Edward Huggins. Born in London in 1832 and orphaned at a young age, Huggins came to the Northwest as a teenager working with the Hudson's Bay Company. He became Fort Nisqually's chief factor and led the 1870 hand over from the British to the United States. He married Letitia Work and became a U.S. citizen in 1857. He was elected Pierce County auditor in 1886. This 1888 tall-towered home at 120 North E St. dominates many Stadium Bowl images; it was demolished in 1949 (pages 29, 66, 70, 73, 84, 86, 87, 93, 94, 96, 126). (Courtesy of Huggins-Johnstone family.)

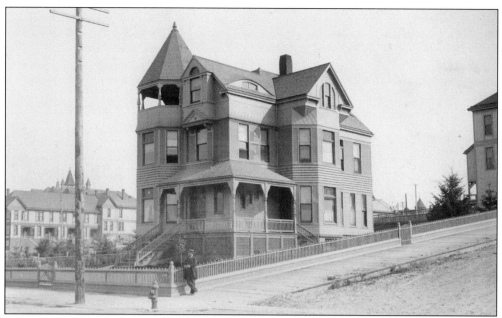

METZLER HOME. Phillip Metzler built this three-story Victorian home at 222 North E St. (on the southwest corner of North Third Street and E Street) in 1890. The original Annie Wright Seminary spire rooftop can be seen in the distance. Wooden sidewalks, dirt roads, and a picket fence are visible. Metzler was president of American Wood Pipe Company. The home was demolished in 1903 to make way for Herr Anton Huth's home. (Courtesy of WSHS-2010.0.54.)

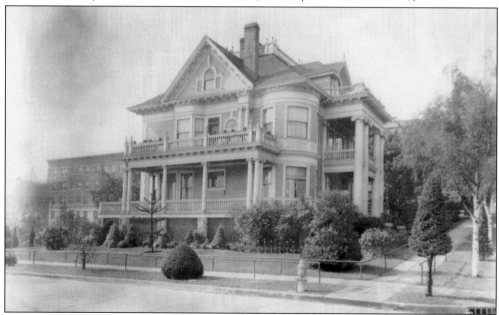

HERR HUTH. Herr Anton Huth had this elegant Colonial home built in 1904 at 504 North Third St., across E Street from Old Woman's Gulch. Born in 1854, Huth learned the trade of brewer and maltster in Darmstadt, Germany. He immigrated to the United States in 1872 and became partners with John Scholl, proprietor of the New Tacoma Brewery. This site is now home to Stadium High School's parking garage. (Courtesy of TPL.)

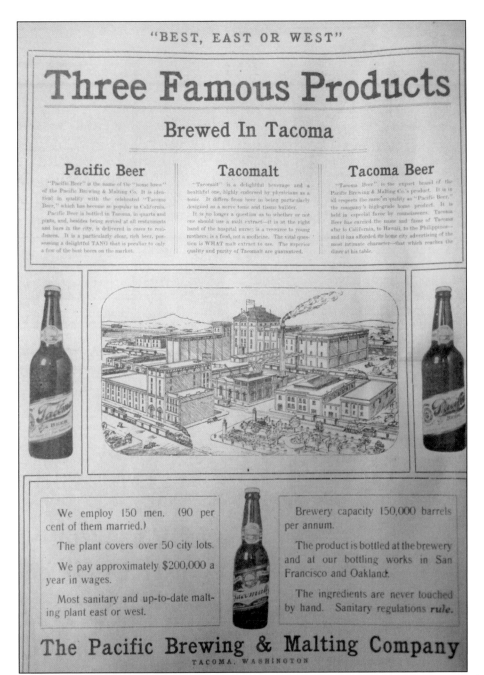

PACIFIC BREWERY. Herr Anton Huth and John Scholl formed a partnership in 1888 known as the Puget Sound Brewery. Three years later Huth bought out Scholl and re-organized with William Virges to form Pacific Brewing and Malting Company. They enlarged their brewery with the purchase of Donaue Brewery and the Milwaukee Brewery, making it the second largest brewer in the state. The company occupied 13 large structures on South 25th Street and Jefferson. Popular labels included Tacoma Beer, Pacific Beer, and Tacomalt. Washington state prohibition went into effect in January 1916, and the brewery was converted to the National Soap Company in 1919. (Courtesy of TDL.)

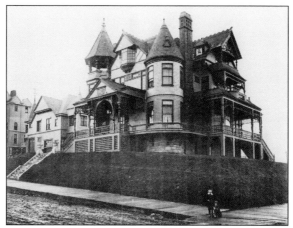

HENRY HEWITT. Awed by the Pacific Northwest forests, Henry Hewitt, cofounder of St. Paul and Tacoma Lumber Company, built his home on Buckley Hill at 501 North Fourth St. in 1889. Designed by architect Andrew Smith, the exterior featured several turrets, copulas, and spires. The interior featured ornately carved wood staircase, paneling, and pocket doors. The three-story castle stood on what was formerly Buckley's Hill and overlooked Old Woman's Gulch, Commencement Bay, and Mount Tahoma. Considered Tacoma's finest home, it was occupied by several different prominent Tacoma families, including Edgar T. Short and E. E. Rhodes. Hewitt was the first president of the Washington State Historical Society and helped found the Tacoma Golf and Country Club, the YMCA, and the Tacoma Riding Club (Woodbrook Hunt Club). The home was demolished in 1957 and the site is a parking lot today. (Both courtesy of TPL.)

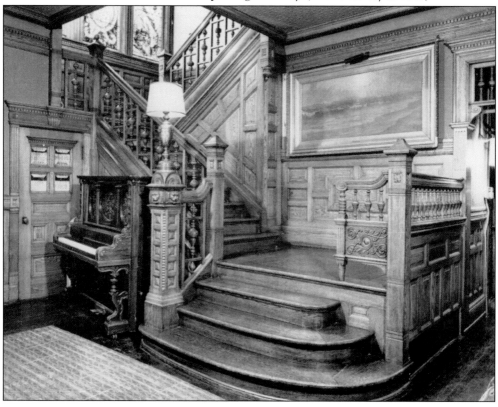

GRIGGS. Within a week of arriving in Tacoma, Col. Chauncey Griggs, cofounder of St. Paul and Tacoma Lumber Company, purchased prime property on Buckley Hill next door to Henry Hewitt and Richard Vaeth. Located at 401 Tacoma Ave. North, the home was completed in April 1889. It boasted three stories with a basement, large dining room, library, billiard room, and a butler's pantry, which were all surrounded by large verandahs and spectacular views. Several clubs, including the Ladies Musical Club, Tacoma Art League, Aloha Club, and the Tacoma Riding Club (Woodbrook Hunt Club), were formed here. The 1909 portrait below honoring Colonel Griggs and his wife Martha Ann (Gullup) Griggs's golden wedding anniversary shows their children, from left to right: Heartie; Everett; Herbert; Theodore; Chauncey Milton (Milt), eldest child; and Anna, the youngest child. Heartie's wedding to Dr. George Wagner on June 7, 1893, was the event of the Tacoma social season. (Above courtesy of WSHS-2010.0.53, below courtesy of TPL.)

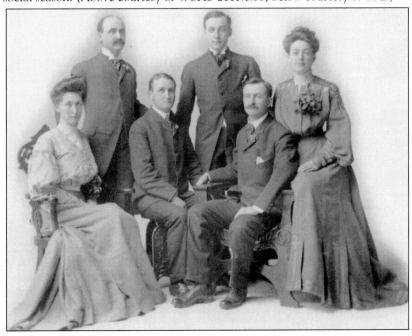

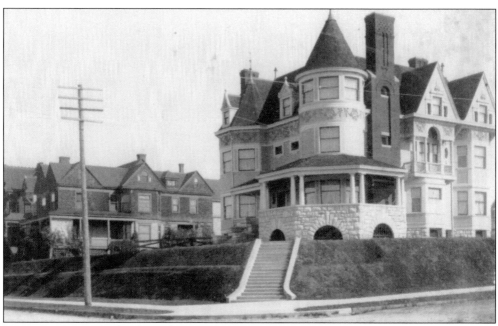

VAETH MANSION. Richard Vaeth arrived in Tacoma in 1884. He was both an optician and a jeweler. Vaeth also served as the president of Pacific Coast Gypsum Manufacturing and was a board member of the National Bank of Commerce. Business thrived, and in 1898, he had this beautiful Queen Anne–style home built at 422 North E St., designed by Russell and Babcock. The interior image below shows Louise (Reno) Vaeth and her two daughters, Hilda and Rhoda. Both daughters were married in front of the bay window in the living room; it had been transformed into a bower with garlands of flowers. Hilda Vaeth married the boy next door, Henry Hewitt Jr., and Rhonda married Vaughn Morrill. Both weddings were described in detail in the *Tacoma Daily Ledger's* society page. (Both courtesy of TPL.)

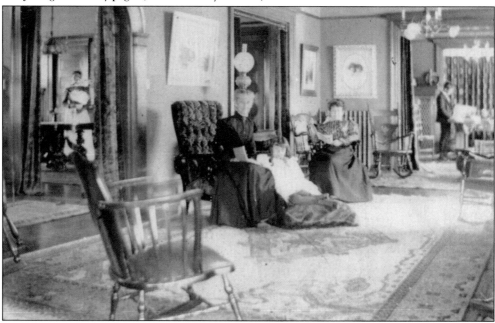

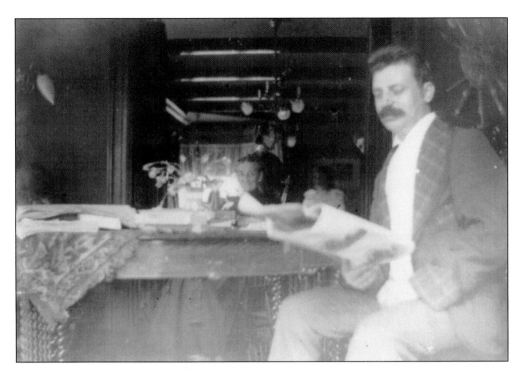

VAETH JEWELERS. Richard Vaeth is captured in a casual pose reading a newspaper at his breakfast table. When he first arrived, Vaeth established a small jewelry store, originally located in the St. John's Pharmacy at Eleventh Street and Pacific Avenue. This location was where the People's Store used to be and where Starbucks is today. Business prospered, and soon he developed a "Tiffany type" establishment. He purchased property on Buckley Hill, and had his home constructed for $15,000. The Vaeth Jewelers advertisement below was published in 1895. (Both courtesy of TPL.)

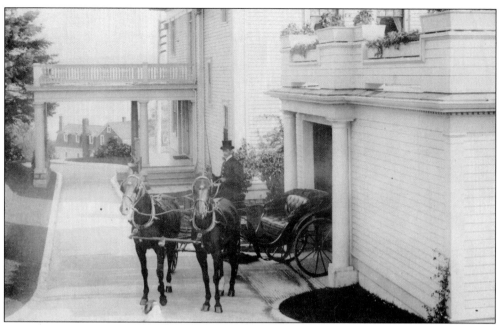

KEEPING UP WITH THE JONESES. The 1888 building boom created competition between neighbors in the Stadium District. Shown in the above photograph is 318 North E St. Neighbors competed with amenities, such as Capt. Everett Griggs's horse-breed and carriage style (above). When automobiles arrived, the horse and buggy competition shifted to the horseless carriage. The 1907 image below was taken of Charles Jones and his wife Franke Tobey Jones at 322 North Fifth St. Jones, the last of the founders of St. Paul and Tacoma Lumber, demonstrated that the soggy land at the mouth of the Puyallup River could be filled and made to support buildings. Jones was a 32nd degree Mason with the Scottish Rite and Mystic Shrine. George Stickney lived here in 1938; his daughter Ann Stickney was a Woodbrook Hunt Club member along with Diane Corse (Thorne), Wendy Wagner (Weyerhauser), and Nancy (Griggs) Daugherty. (Above courtesy of TPL, below courtesy of WSHS-2006.0.625.1.)

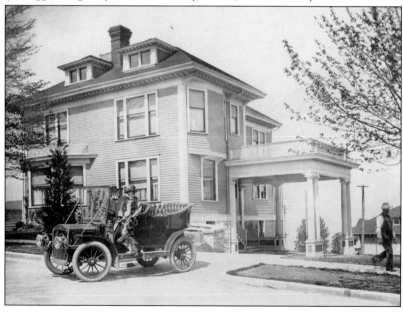

424 NORTH D ST. The home located at 424 North D St. was built in 1889 and designed by Daniels and Cook, architects for William Fraser. Charles Jones and his wife Franke Tobey Jones (page 44) incorporated "Restholme" in 1922 and leased this house, which they furnished with their own antiques. This home was the precursor to the Tobey Jones Retirement Home. The house was demolished in the 1930s. Anita Thorne Corse built a Georgian manor–style home here in 1938. (Courtesy of TPL.)

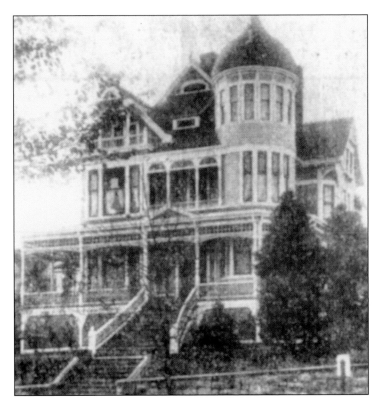

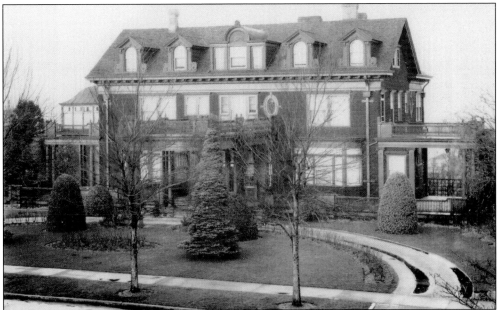

417 NORTH E ST. This Georgian-style home was built in 1906 for George Lewis Gower, timber baron. He lived at this home until his death in 1920. The house was designed by the architectural firm Russell and Babcock. Chester Thorne's daughter, Anita Thorne Corse, purchased the house in 1920 and sold it to J. P. Weyerhaeuser Jr. after Corse-Stone relocated to Thornewood Estate in Lakewood in 1935. (Courtesy of TPL.)

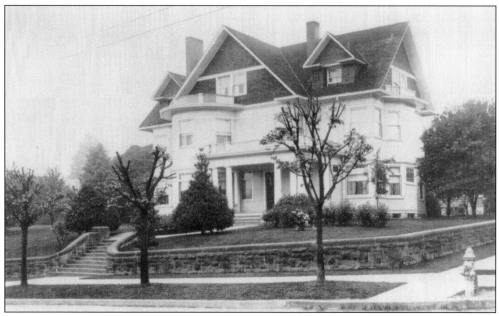

320 TACOMA AVE. NORTH. The home pictured above was designed by F. S. Sexton and built in 1890 for Louis Campbell, the mayor of Tacoma in 1900. In 1901, Alec "King of the Klondike" McDonald purchased it. Judge William H. Snell purchased the house in 1906. Frost Snyder and his family purchased and moved into it in 1942. Frost Snyder was the president of the Aloha Club. His family was active in the Woodbrook Hunt Club. Below is the Snyder family's library, which is furnished with ample books and reading chairs. Frost Snyder was president of Clear Fir Lumber as well as Vancouver Plywood and Veneer. The Snyder family later moved to the Lakewood area, and in 1956, the house was demolished. Vista Terrace apartments were built on this location in 1966. (Both courtesy of TPL.)

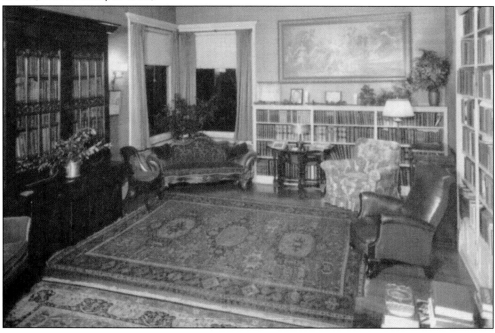

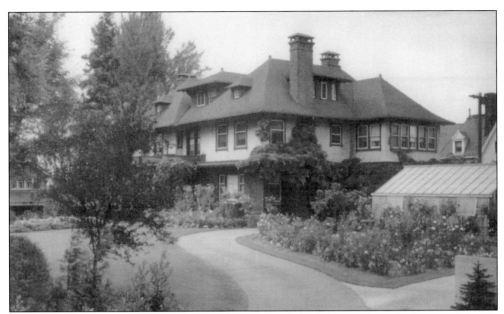

CHARLES HYDE HOME. This modern English style home located at 425 North Tacoma Ave. was designed by E. A. Wager and built in 1905. The original homeowner, Charles Hyde, was also the owner of West Coast Grocery, one of the oldest wholesale groceries in the Pacific Northwest. The Hydes were equestrian enthusiasts and Woodbrook Hunt Club members. Charles Hyde Jr. was an avid polo player. Hyde family members belonged to the Elks, Tacoma Yacht Club, Union Club, Tacoma Lawn Tennis, Fircrest Golf Club, and Tacoma Golf and Country Club. Charles Hyde was a trustee of the Ferry Museum (which became WSHS). Ensuing homeowners include: Harold Allen, Allen Realty Company; George and Alice Franklin, who were awarded second place in the 1947 *Tacoma Times* House Beautiful contest; and the First Lutheran Church. Below is an interior view of the home decorated for the holidays in 1949. (Both courtesy of TPL.)

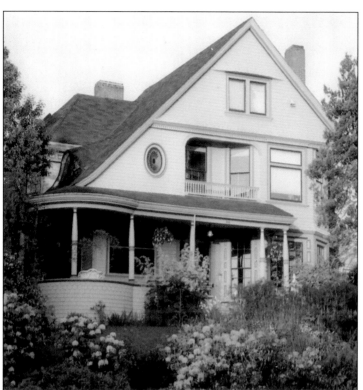

CHINABERRY HILL. Built in 1889 for Lucius Manning, the Victorian house located at 302 Tacoma Ave. North was designed by Proctor and Dennis Architecture firm. E. O. Schwagerl was the landscape architect. Manning was involved with the banking business and real estate. Other owners include Edward and Mary Brady (1915–1940), Rutherford and Edna Barnett (1941–1991), and Larry Williams. In 1996, Cecil and Yarrow Wayman turned it into Chinaberry Hill Bed and Breakfast. (Courtesy of Chinaberry Hill Bed & Breakfast.)

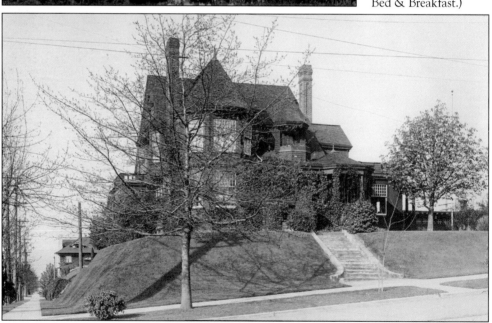

SENATOR FOSTER. This Victorian home at 601 Tacoma Avenue, designed by Oliver P. Dennis, was built in 1892 for Charles Marble. Sen. Addison Foster purchased it in 1905. The home features a large reception room and stairwell finished with oak-paneled ceilings and wainscoting; the library and parlor are finished in sycamore. Foster, vice-president of St. Paul and Tacoma Lumber, arrived in Tacoma in 1888. A Republican, he served in the U.S. Senate from 1899 to 1905. (Courtesy of WSHS-1981.94.463.)

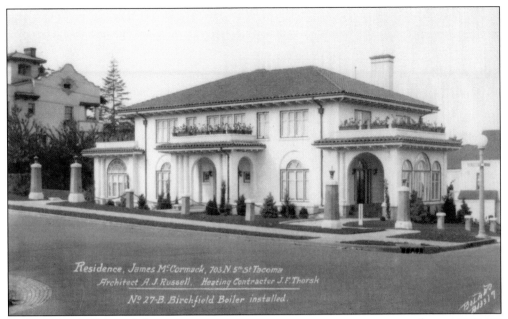

Residence, James McCormack, 705 N. 5ᵗʰ St Tacoma
Architect A. J. Russell. Heating Contractor J. F. Thorsk
N⁰ 27-B. Birchfield Boiler installed.

McCormack's. Pictured above is a modified Spanish Colonial home at 705 North Fifth St. that was designed by Ambrose J. Russell and built for James and Elizabeth McCormack in 1924. James McCormack was the president of McCormack Brothers Department Store, a popular men's clothing store in downtown Tacoma. The home featured a large living room, solarium, smoking room, library, and deck. Maid's quarters were on the third floor. The basement had a social and billiards room. Oak and mahogany are featured throughout. It currently is the Villa Bed and Breakfast. At right is a 1910 advertisement for McCormack's Men's Furnishings that illustrates the high styles and cost for men's fashion of the era. (Both courtesy of TPL.)

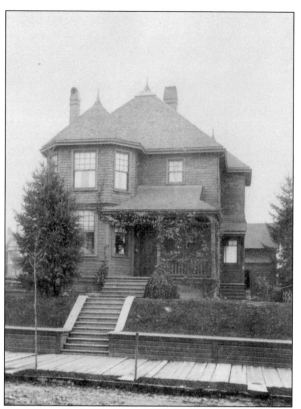

416 North Yakima. Pres. Abraham Lincoln appointed Joseph "Old Cush" Cushman and Arthur Denny to the positions of receiver and registrar, respectively, in the General Land Office in Olympia, Washington Territory. Joseph's son, William Hedge Cushman, started his business career in 1860 as a teenager selling hand-drawn maps of land sold by his father to gullible land speculators. William became very skillful in selling Northern Pacific land grants and built a home at 416 North Yakima in 1888. Lucretia "Crissie" Johnson married W. H. Cushman on July 6, 1878. The image below shows her collection of Northwest Native American baskets filling an entire room at their home. Oblivious to the fact that the hand-made baskets might be considered valuable, children played among them. (Both courtesy of Roger Cushman Edwards.)

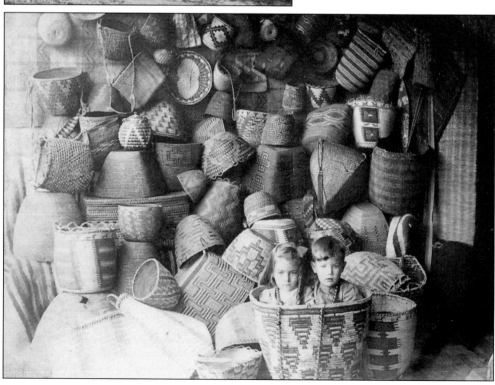

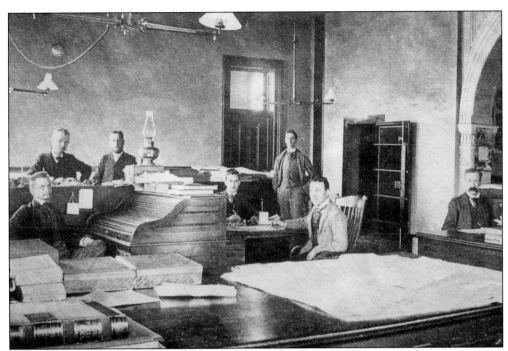

INTERIOR WORKPLACE. William Hedge Cushman is working as head cashier for the Tacoma Land Company in the new NPRR headquarters on Pacific Avenue in 1888 (above). Pictured below is Freeman Hedge Cushman, Stanford University class of 1904, working in the old city hall of Tacoma, which was across the street from NPRR headquarters. Freeman, through his father William's Royal Arch Masonic connections to Tacoma's city government, got a job in the Tacoma Engineering Department and was promoted to assistant city engineer prior to World War I. Tacoma had the commissioner form of government, and Freeman worked in the office under the commissioner of light and water. (Both courtesy of Roger Cushman Edwards.)

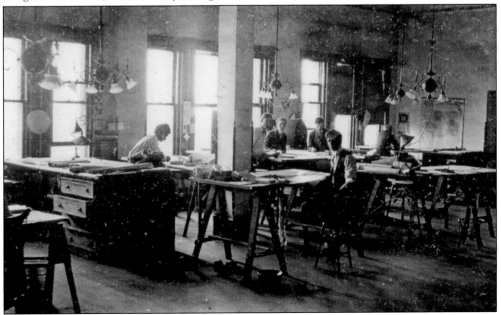

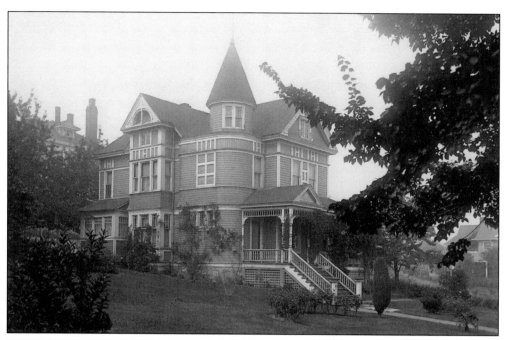

618 North G St. Fredrick C. Miller obtained his medical license in 1884 and moved to Tacoma shortly thereafter. Dr. Miller's practice was located at 1201 Pacific Ave. The first home built in 1888 by Dr. Miller at 618 North G St. was destroyed by fire in 1889. This second Miller home was built the same year. Dr. Miller traveled to the Yukon during the 1897 gold rush and brought a portable medical kit with him. He mined gold and had a gold-nugget tiepin, which he wore for many years, made out of the gold he found. This home was demolished in 1948 and a new one built. (Both courtesy of Mary Bowlby.)

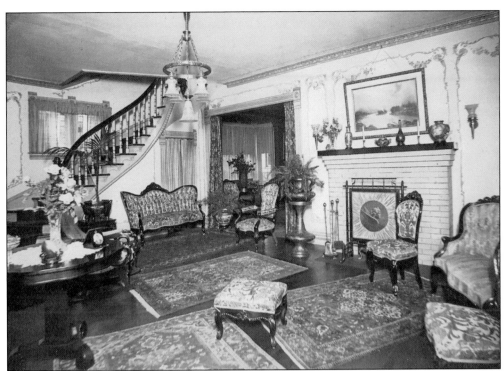

FREDRICK C. MILLER JR. An avid entertainer, Mrs. Frederick Miller Sr. decorated her home in the Louis XIV period scheme, which included French gray and pale pink panels featuring festoons of roses. The ceiling was paneled in the same tints, and the theme was carried up the main staircase. The electric light fixtures were in keeping with the Louis XIV effect (above). Dr. Miller's son, Fredrick C. Miller Jr., Tacoma High School class of 1910 (right), played in the very first 1910 football game in Stadium Bowl (page 90). Miller Jr. married Margaret More. Considered to be a woman before her time, she was the first in Tacoma to get the 1920s bob-cut hairstyle. When the button on her pantaloons popped, the pantaloons dropped, and she stepped right out of them and into a taxi. Her pantaloons were last seen on the street in front of Tacoma Theater. (Both courtesy of Mary Bowlby.)

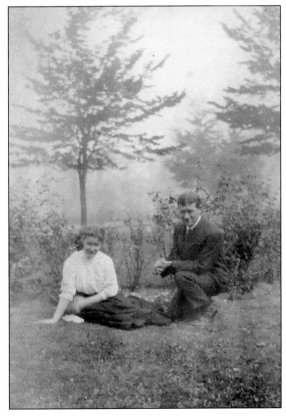

210 North Yakima. The vast majority of the homes that were built between 1887 and 1910 were modest cottage style homes. The gray stone Pattern Book house at 210 North Yakima (above, left) is an ideal example of the average home in the Stadium District. Built in 1908, the house was purchased by the Barr family in 1912. Sadly, their daughter-in-law Mary Eugenia Barr (left) died young in 1921, leaving her husband Stevenson E. Barr and two daughters Kathleen and Mary, 4 and 12 years old respectively. To help with the family loss, Stevenson and his two daughters moved in with their grandmother, Susan Elizabeth Barr, and this house became a multi-generational home. (Above courtesy of Amberose Longrie, left courtesy of Barr-Smith.)

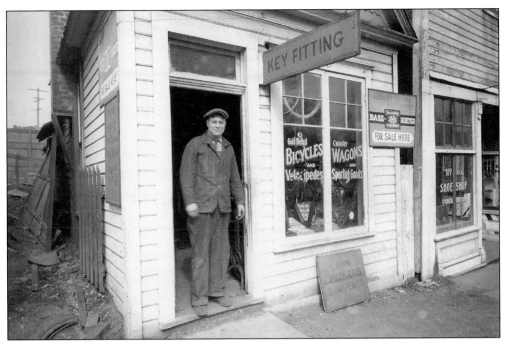

BARR BICYCLE SHOP. Stevenson Barr was a handyman who made house calls with his horse and buggy. He started fixing bicycles in his garage. One day a neighborhood kid asked, "Why don't you start your own business?" That is exactly what Barr did. Gradually, he added a lawn-mower repair and locksmith business to his trade and moved into the shop at Division Avenue and I Street, across from Wright Park. (Courtesy of Barr-Smith.)

KATHLEEN BARR SMITH. Kathleen moved into 210 North Yakima in 1921 and still lives there. She loved dancing, riding ponies, and playing in Wright Park. A member of the SHS class of 1936, she married her SHS sweetheart, Warren Smith, in 1939, and they celebrated their 61st wedding anniversary in 2000. Warren was an electrician. Kathleen worked at the downtown Bon Marche and Nordstrom's at Tacoma Mall. Over 18 family members, spanning four generations, are Stadium graduates. (Courtesy of Barr-Smith.)

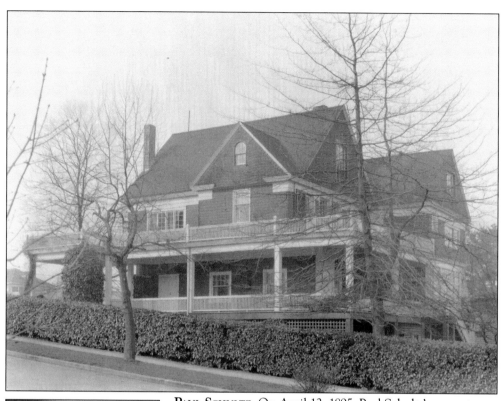

PAUL SCHULTZ. On April 12, 1895, Paul Schultz's servant found him dead in his bedroom at 601 North Yakima with a bullet hole in his temple. Schultz, 33-year-old NPRR land agent, had been living in high style since he arrived in Tacoma. He had wonderful horses, a handsome carriage, and a house of splendor, all of which caught the attention of his NPRR superiors, who initiated an investigation. They found that Schultz had embezzled $1.5 million (approximately $40 million today), robbing one company to invest in another. Born in Germany in 1848, Schultz arrived in the United States in 1868 and in Tacoma in 1888. He was described as domineering, hot-tempered, and vain. The house was later bought by William Jones and hosted Pres. Theodore Roosevelt when he visited Tacoma in 1903 to lay the cornerstone of the Masonic Temple. (Above courtesy of TPL, left courtesy of TDL.)

PAUL SCHULZE
COMMITS SUICIDE

The N. P. General Land
Agent Found Dead
in His Bed.

Japanese Servant Made the
Startling Discovery at
4 P. M.

Ate Breakfast in His Room and
Soon After Fired the
Fatal Shot.

But One Bullet Used and That Went
Through the Brain of the
Unfortunate Man.

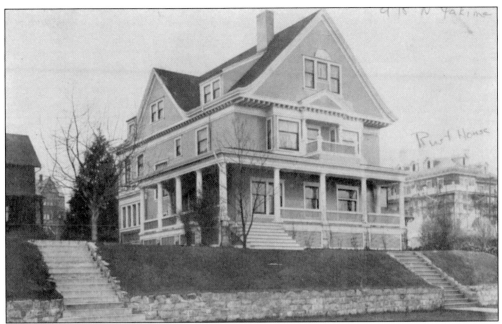

SENATOR METCALF'S HOME. These 1906 images are of Senator Metcalf's Colonial Revival–style home at 918 North Yakima. Metcalf was the editor of the *Tacoma Morning Globe* in 1889. He became president of Metcalf Shingle Company in 1894. Elected on the Republican ticket to Washington state senate, he served from 1906 to 1939. He sponsored the "square deal combination," which overthrew the old political ring that controlled the senate, obtained power to name committees, and banished lobbyists from the capitol. He helped establish the Federal Farm Loan Act. A member of the Freemasons, Metcalf achieved Knights Templar, 33rd degree in the Scottish Rite. He belonged to the Union/University Club, Benevolent and Protective Order of Elks, Modern Woodmen of America, the Chamber of Commerce, and Tacoma Golf and Country Club. Shown below is the interior of the home, which features extraordinary old-growth woodwork throughout including huge pocket doors. (Both courtesy of WSHS; above 2010.0.275, below 2010.0.271.)

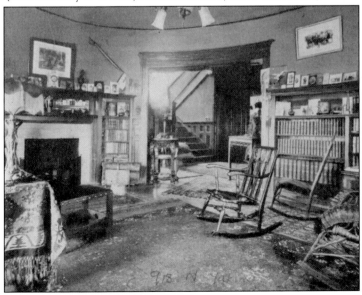

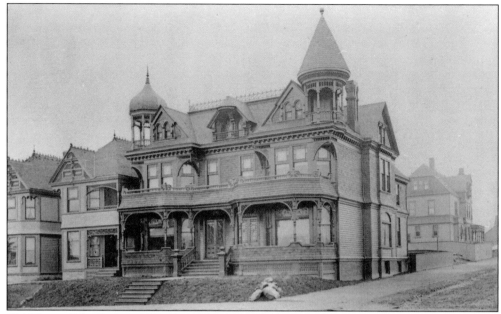

324 NORTH I ST. Built in 1890, this Italianate-style duplex still exists today. The turrets, cupola, and upper-floor dormers were removed after the 1949 earthquake. North I Street was still dirt in this 1890s image; wooden sidewalks and streetcar rails can be seen. Close to Wright Park and across the street from Parkway Tavern (page 111), this multi-family dwelling is located along today's Point Defiance bus route no. 11. (Courtesy of WSHS-2010.0.274.)

RHODES HOME. In 1901, Job Carr's Mountain or Mount Ainsworth was the site Albert Rhodes chose to locate his Tudor-style home at 702 North I St. His brother Henry Rhodes built his Queen Anne–style home at 701 North J St. on the adjoining property. The Rhodes brothers became partners and opened one of Tacoma's largest and most beloved department stores, Rhodes. Henry moved to Rhodesleigh on Lake Steilacoom, Lakewood, in 1921. (Courtesy of TPL and TDL.)

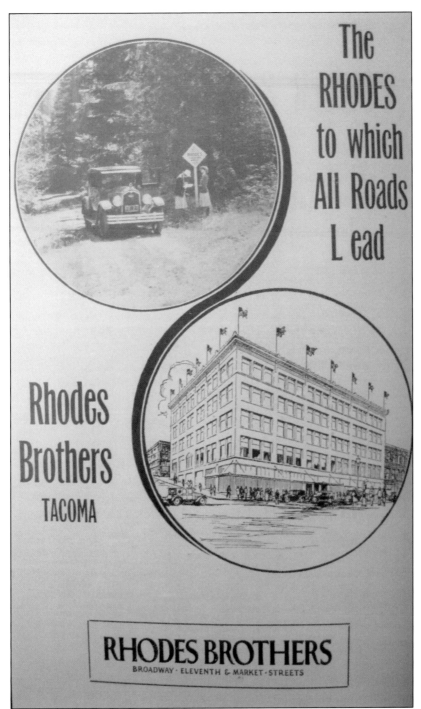

ALL ROADS LEAD TO RHODES. This advertisement from around the 1890s appeared in the Tacoma Polk Directory. Henry Rhodes established Rhodes Brothers Inc., a small tea and coffee storefront downtown, in 1892. Gradually, he expanded to include glass, crock ware, stationery, and books. Henry was joined by his brothers Will and Albert in 1900 and expanded to a full mercantile house. Rhodes closed in 1974 after the Tacoma Mall was opened. (Courtesy of TPL-Polk.)

RUST MANSION I AND II. Shown above is the first of three homes that William Rust lived in. Located at 723 North I St., the cottage-style mansion was built in 1885. Below, 1001 North I St. is the second home that Rust built in Tacoma. The Colonial-style mansion built of Wilkeson sandstone was built in 1905 for $122,000. The furnishings cost an additional $55,000. Based on John A. McCall's home design in Long Island, New York, which cost $2 million, the mansion featured a ballroom, billiards room, cigar room, and library. It was notorious for speakeasies during Prohibition. With the unexpected death of Rust's son Howard, he decided to build a new home at 521 North Yakima in 1912 (page 61). Rust was a Freemason and belonged to the Union Club, Elks, and the Tacoma Golf and Country Club. (Above courtesy of A. Longrie, below courtesy of WSHS-1981-94-461.)

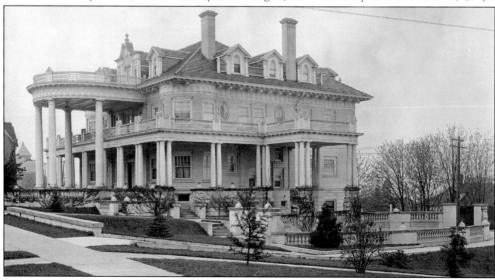

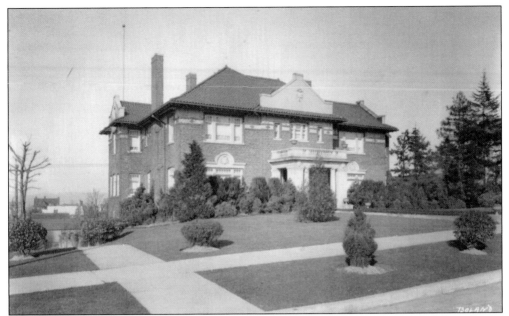

RUST MANSION III. This home located at 521 North Yakima Ave. is the third of three homes that William R. Rust built (page 60). This Mediterranean-style home was built in 1912. Rust arrived in Tacoma in 1887 and became manager of the Tacoma Smelting and Refinery Company in 1890. His granddaughter, Billie Jean (Murphy) Rust, an avid equestrian, was the master of the fox hounds with the Woodbrook Hunt Club. (Courtesy of TPL.)

LOWELL ELEMENTARY. Established in 1869, Tacoma's oldest public school was originally called First Ward School and was later changed to Lowell. The original school building was moved to the Aquinas School site in 1899. George Weyerhaeuser was in Mrs. Lucille Berg's third-grade class at Lowell Elementary School on May 24, 1935. As usual, George walked from Lowell to Annie Wright Seminary to meet his sister Ann to go home for lunch. (Courtesy of TPL-BU-11324.)

61

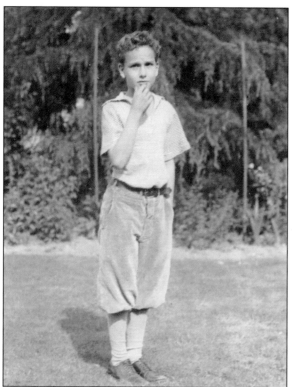

GEORGE WEYERHAEUSER. Son of John P. and Helen Weyerhaeuser, George was just nine years old when he was nabbed from his Stadium-Seminary neighborhood. He was on his way home from Lowell School to meet his sister, who was only five blocks away, when he was kidnapped near the Tacoma Lawn Tennis Club courts on the grounds of Annie Wright Seminary. (Courtesy of TPL-27952.)

KIDNAPPED! The road from North Tacoma Avenue between the present location of Annie Wright Seminary and the Tacoma Lawn Tennis Club was believed to be the location where third-grader George Weyerhaeuser was kidnapped. (Courtesy of Amberose Longrie and Logan Ryesmus.)

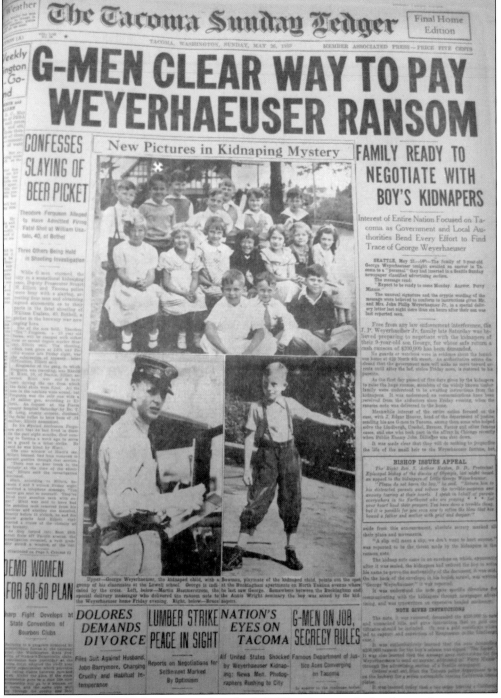

The Tacoma Sunday Ledger

TACOMA, WASHINGTON, SUNDAY, MAY 26, 1935 MEMBER ASSOCIATED PRESS — PRICE FIVE CENTS

Final Home Edition

G-MEN CLEAR WAY TO PAY WEYERHAEUSER RANSOM

CONFESSES SLAYING OF BEER PICKET

Theodore Ferguson Alleged to Have Admitted Firing Fatal Shot at William Usatalo, 40, at Bothel

Three Others Being Held in Shooting Investigation

New Pictures in Kidnaping Mystery

FAMILY READY TO NEGOTIATE WITH BOY'S KIDNAPERS

Interest of Entire Nation Focused on Tacoma as Government and Local Authorities Bend Every Effort to Find Trace of George Weyerhaeuser

BISHOP ISSUES APPEAL

NOTE GIVES INSTRUCTIONS

DEMO WOMEN FOR 50-50 PLAN

Sharp Fight Develops at State Convention of Bourbon Clubs

DOLORES DEMANDS DIVORCE

Files Suit Against Husband, John Barrymore, Charging Cruelty and Habitual Intemperance

LUMBER STRIKE PEACE IN SIGHT

Reports on Negotiations for Settlement Marked By Optimism

NATION'S EYES ON TACOMA

All United States Shocked by Weyerhaeuser Kidnaping; News Men, Photographers Rushing to City

G-MEN ON JOB, SECRECY RULES

Famous Department of Justice Aces Converging on Tacoma

RANSOM! The *Tacoma Ledger* reports that the J. P. Weyerhaeuser Jr. family was "preparing to negotiate with the kidnappers of their 9-year-old son George, for whose safe return a cash ransom of $200,000 has been demanded . . . five days were given by the kidnappers to raise the huge ransom." Neighbors recall that the Weyerhaeusers put a white sheet in the window overlooking Stadium Bowl as a signal to the kidnappers. (Courtesy of TDL.)

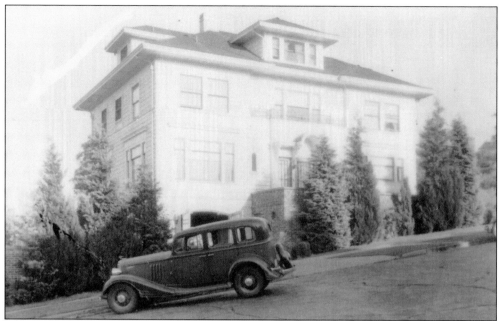

WEYERHAEUSER HOME. In 1935, the Weyerhaeusers made their home at 420 North Fourth St. Built in 1924, the Colonial-style home was located one block from Stadium Bowl. George was the grandson of Frederick Weyerhaeuser, founder of Weyerhaeuser Timber Company; Frederick purchased 900,000 acres of timberland from NPRR and managed 4 million acres nationwide. George's father, John, led the company from 1933 to 1956 and helped establish the industry standard for sustainable harvest. (Courtesy of TPL.)

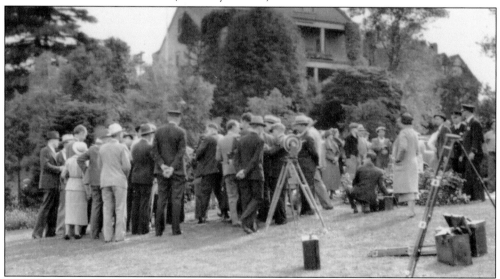

NATIONAL NEWS. Press from around the world descended upon Tacoma to report this sensational crime story. A ransom demand for $200,000 (approximately $3 million today) was made and paid. George was released unharmed on June 1, 1935. The kidnappers were sentenced to Alcatraz Island Penitentiary. George grew up to become president of Weyerhaeuser Company and married Wendy Wagner at the Lakewold Estate. The Weyerhaeusers later gave one of George's kidnappers a job at Weyerhaeuser Company. (Courtesy of TPL.)

Four

THE BROWN CASTLE

There are certain places in the world that people consistently recognize as extraordinary. The location we know today as Stadium High School, affectionately called the "Brown Castle," is one of them. The site is located on a prominent bluff with extensive views of Commencement Bay, the Olympic and Cascade Mountains, and magnificent Tacobet, or Mount Tahoma (Rainier).

The Puyallup tribe considered this a sacred place. Samuel Wilkeson of the NPRR immediately recognized the incredible potential the location afforded. The Blackwells recognized the special significance and purchased and cleared the land for their home in 1877. On the first Sunday Isaac Anderson, manager of Tacoma Land Company, spent in Tacoma in 1884, he walked from Blackwell Hotel to Old Town following the beach. He returned over the hill along the bluff's Beach Trail. He saw this site and immediately recognized the incredible qualities the location afforded.

In February 1889, the Tacoma Land Company purchased nine acres from Anderson and Blackwell, which included the newly constructed home of the Blackwell family, for $86,000 (approximately $2 million today) to build a new Tourist Hotel. According to W. P. Bonney, even considering the speculative prices of the time, it was a very high price. The hotel was designed to be the best on the West Coast. Construction began in 1890. The 1893 financial panic halted the project. The building, vacant for five years, was gutted by fire in 1898. The ruins stood empty for another six years. In 1903, the owners contracted to demolish the building. On that same day, school board members recommended converting the charred hotel to a school. School Board president W. B. Coffee consulted architect Frederick Heath, who supported the idea. By noon, the Tacoma School District had purchased the land and building for $34,000. A lawsuit was filed against the sale alleging extravagant costs. Courts verified the sale, renovation began in 1904, and the new Tacoma High School opened on September 10, 1906.

Today the Brown Castle is a symbol of civic pride and an icon of the region, representing the community's hopes and aspirations. This extraordinary place empowers past, current, and future leaders who emerge prepared to go out into the world to leave a positive legacy for future generations.

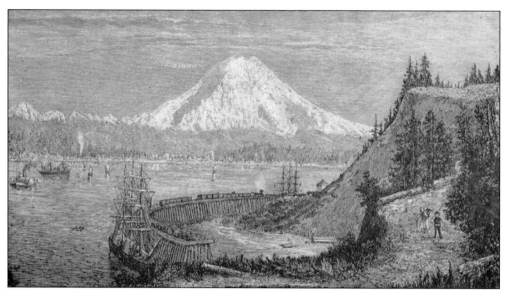

BLACKWELL'S POINT. Many of the scenic images illustrating the magnificent Tacoma views are from a special place, the bluff above the NPRR wharf and coal bunkers. William Blackwell purchased it for $25 per lot. As a girl, Ruby Blackwell would accompany her parents to the bluff in the evenings to check on the land clearing, logging, and slash burning. Each evening they returned home via muddy roads, exhausted and smelling like smoke. (Courtesy of TPL-5434.)

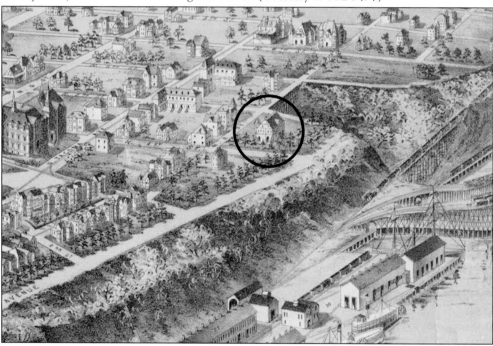

BLACKWELL'S HOME: Built in 1888, William and Alice Blackwell's home was originally located where Stadium High School is today. They were just finishing their home when NPRR and Tacoma Land Company purchased the property for the proposed Tourist Hotel. The Blackwells moved the house to 32 E St. It was later converted to the Jones Boarding house and was demolished in the 1930s. (Courtesy of WSHS-1968.25.1.)

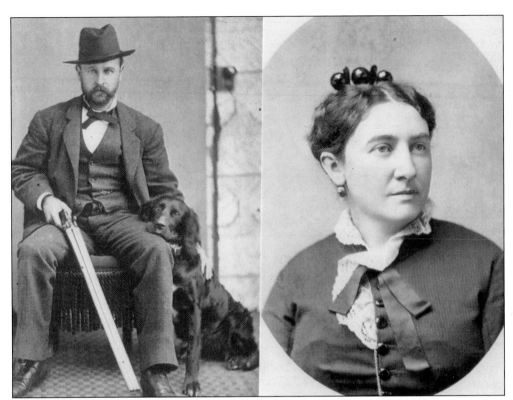

BLACKWELL FAMILY. Originally from Connecticut, the Blackwells moved west and ended up in Tacoma with the NPRR. They managed the Blackwell Hotel in 1874 (page 25). Pictured above with his dog, Belle, in Tacoma in 1888, William was born in Milford, Connecticut, in 1837. He married Alice Bliven (upper right) in Bridgewater, Connecticut, in 1863. In addition to managing the Blackwell Hotel, they later managed the Tacoma Hotel. The Blackwells built and lived in several homes in the Stadium District, which included their original home at the site of Stadium High School (page 66). Ruby Blackwell (right) was adopted at age seven and grew up to be a long-time Tacoma Public School teacher. She lived to be 103 years old. Ruby is pictured at right with her dog Blackie. The Blackwells helped found the Humane Society and YWCA (page 116). (Above courtesy of WSHS-1979-68-113.2, right courtesy of WSHS- 1979.68.113.5.)

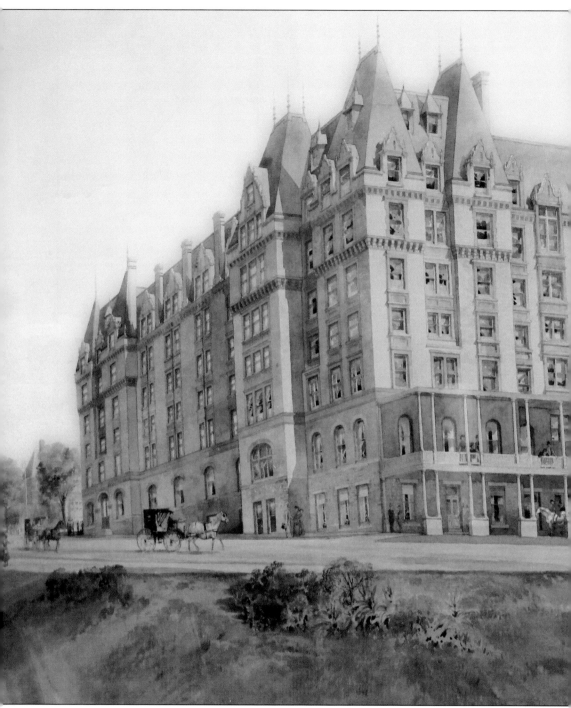

TOURIST HOTEL. This original 1890 oil painting of the Tourist Hotel hangs in Stadium High School today. The French chateau–style hotel was to be the finest on the West Coast. Designed by Hewitt and Hewitt of Philadelphia, the seven-story structure built of stone, brick, and terracotta was to have 250 guest rooms. The billiards room and bar were proposed to be in the first basement with a large open-aired covered porch overlooking Cliff Avenue with mountain and marine

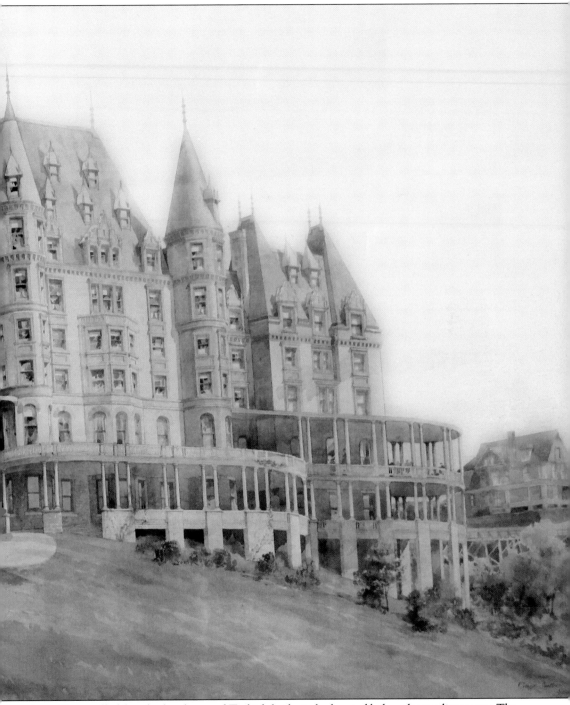

views. Plans called for a barbershop and Turkish baths to be located below the reading room. The servant's dining room, the bakery, and a wine room were planned for the lower basement. Notice the Victorian homes along E Street. The gentleman mounted on an elegant horse in top hat and scarlet coat, surrounded by hounds (center, under verandah), represents a centuries old tradition, which is continued today by Stadium graduates at Woodbrook Hunt Club. (Courtesy of SHS.)

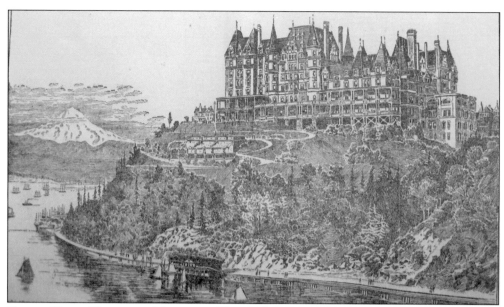

TOURIST HOTEL. The turrets of the proposed French chateau–style hotel stand majestically overlooking Commencement Bay and Mount Tahoma. You can see the natural shoreline and Old Woman's Gulch in the lower right. The home to the left of the hotel was William Blackwell's. It was moved to First and E Streets so that the Tourist Hotel could be built. (Courtesy of WSHS-1955.10.1.)

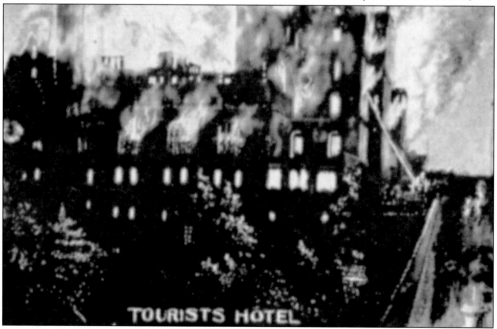

FIRE! By May 1893, construction was 50 percent complete, and NPRR had invested $480,000 when a national financial panic halted the project. The building stood vacant for five years. On the evening of October 11, 1898, George Kahler was passing by the vacant Tourist Hotel when he noticed heavy smoke coming from the northwest corner. Five fire engines fought the blaze, but the water mains proved inadequate to snuff the blaze. Within 30 minutes, the interior was engulfed in flames. The fire's glow could be seen 35 miles away in Olympia and Seattle. (Courtesy of TPL.)

WHAT TO DO WITH GLOOMY RUINS?
The *Tacoma Ledger* reported, "Bare and blackened walls now mark the site of the most significant hostelry in the Northwest." The gloomy ruins stood empty for nearly six years while locals debated its future. They began dismantling the building's facing bricks to build new train depots in Idaho and Montana; meanwhile, Tacomans struggled with an overcrowded high school. Walking to work one morning from their homes, Conrad Hoska, Eric Lusling, and Alfred Lister (former school board members), noticed men dismantling the structure. They stopped by the School Board president William B. Coffee's office to discuss converting the hotel to a school. Coffee called architect Frederick Heath, who supported the proposal. By noon, the Tacoma School District had purchased the building for $34,000. (Right courtesy of TDL, below courtesy of WSHS 1968.115.2)

PRICE FIVE CENTS.

HOTEL WALLS APPEAR GLOOMY AND BARE

Melancholy Air Pervades the Smouldering Ruins of Tacoma's Most Recent Damaging Conflagration.

STRONG SUSPICION OF INCENDIARISM

One Man Declares He Saw Kerosene Trickling From Two Cans Lying in the Vacant Hallway Last Sunday.

FIREMEN ANSWER CHARGES OF INCOMPETENCY

Chief Poynes Shows That the Flames Had Enveloped the Whole Structure Before Alarm Was Sent, and His Men Struggled Heroically.

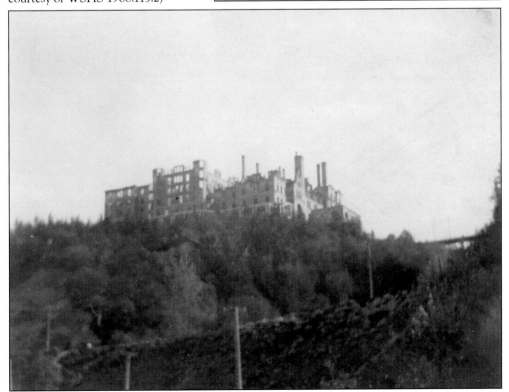

Tenino quar-
on the entire
charge of the

the building
n expenditure
ted the total
t sum. Plans
wn by Archi-

P IN

G OFFICE

or Criticising
ireater

NEW HIGH SCHOOL OPENS DOORS TODAY

FINEST BUILDING OF ITS KIND IN THE UNITED STATES.

After Two Years of Continuous Work Property That Was Purchased for $35,000 Has Been Improved to Be Now Worth Over $500,000—Site Is Unequaled.

ment. Here
domestic scien

Triumph

The heating
which is ente
walls and whi
below the roof
side windows
Beesides the
quarters, here
storerooms.
Frederick He
tainly achieved
ing of the Ta
careful attentic
and ventilation
detail are rarel
ing of this char
ucation belong
liberality in th
No finish or m
to use in the
consequence Ta
of the finest hi
country, and o

SEPTEMBER 10, 1906. *The Daily Ledger* reported, "Tacoma's magnificent High School, the finest in the United States will open its doors to the advanced pupils of the city schools this morning. Rising from a bluff, with a superbly commanding view of the beautiful harbor of Tacoma, the noble structure resembles some old castle of centuries ago . . . It is impossible to adequately describe its beauties and still give a correct idea of its huge proportions . . . The building has over 50 classrooms. The front entrance has a huge granite step that stretches the whole width of the vestibule, quarried from Fern Hill and hauled by a 26-horse team to the site. The school features a central telephone system, a gymnasium in the basement, a hospital room and a small, but adequate, kitchen along with perfect lighting and ventilation throughout." (Above courtesy of TDL, below courtesy of TPL.)

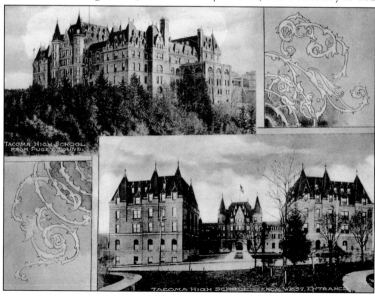

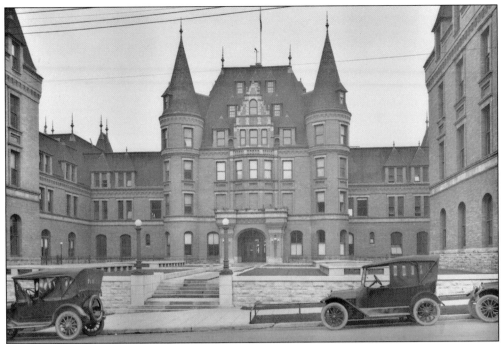

E STREET. When the new Tacoma High School opened in 1906, there was no stadium. The school name changed to Stadium High School in 1913 after the stadium was built and Lincoln High School was under construction. E Street was a through street until 1987. Shown below are several elegant homes that were immediately across the street from Stadium. The far left home belonged to Edward Huggins, factor, Hudson's Bay Company (pages 37, 66, 94). (Above courtesy of WSHS-1957.64.B141591, below courtesy of WSHS-1957.64.B1689.)

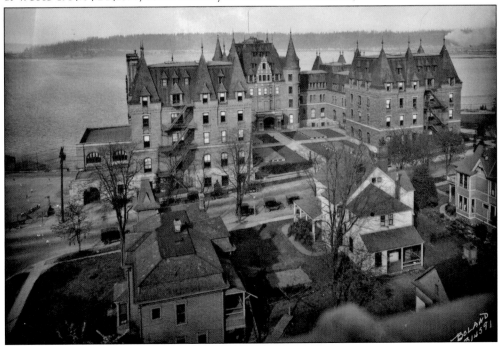

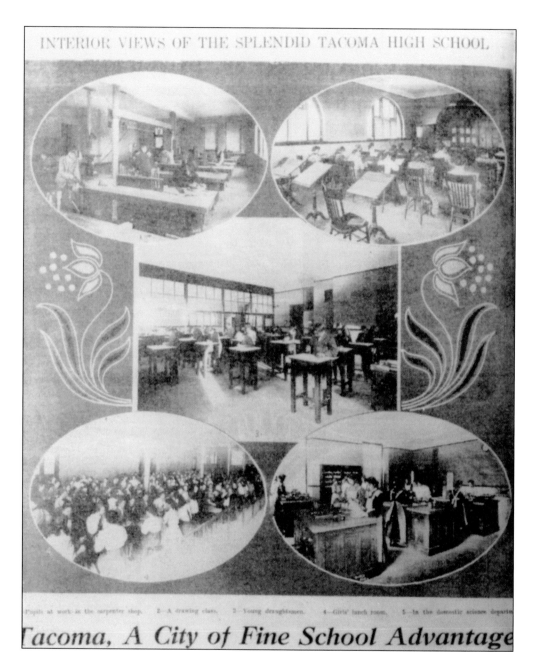

Tacoma, A City of Fine School Advantage

CLASSROOMS. This 1906 Tacoma *Daily Ledger* full-page layout allows a glimpse into what classrooms looked like over a century ago. This layout features traditional classrooms as well as specialized facilities such as a carpentry shop, art, drafting, domestic science department, and a separate girl's lunchroom. Girls were required to wear long non-revealing dresses. Boys wore white shirts and jackets or sweaters with their knickers. (Courtesy of TPL.)

THE TAHOMA. The annual yearbook of Stadium High School has been called *The Tahoma* since it was first published in the 1890s. In addition to class pictures and activities, *The Tahoma* often featured historical articles related to Native American legends of the mountain, gulch, and the school site. (Courtesy of Iris Bryan/ Faye Langston, SHS class of 1925.)

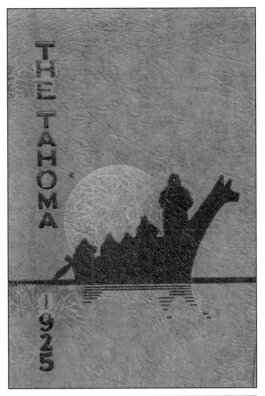

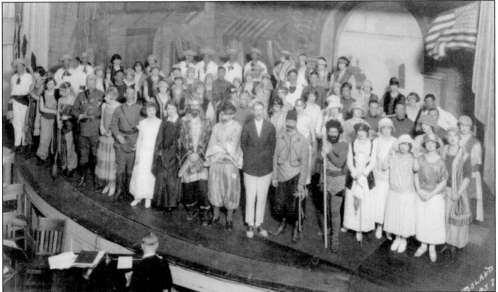

STAGE FRIGHT. Another special feature is the second-floor stage where operas, dramas, and comedies were performed and accompanied by a wonderful pipe organ. Stadium has had several graduates who went on to stardom: Beatrice Blinn and Mildred David went on to star in silent films. Other stars of the silver screen include Rosemarie Bow, Herman Brix (stage name Bruce Bennett), Janis Paige, and Marjie Millar. Stadium High School itself was featured in the 1999 movie *Ten Things I Hate About You.* (Courtesy of TPL.)

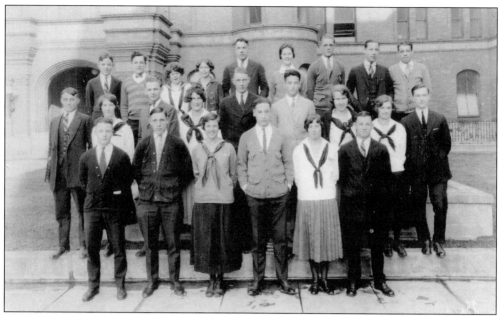

1925 Student Council. Future leaders sometimes self-select into high school activities. This image is of the 1925 student council. Council president Joseph Griggs (page 41) and Iris Bryan (page 117) are in the second row on the left. Major accomplishments of the 1925 council included fixing the drainage system on North First and Tacoma Avenue and establishing an Honor Society. Student styles change, and the girls' skirt hems were getting shorter. (Courtesy of TPL.)

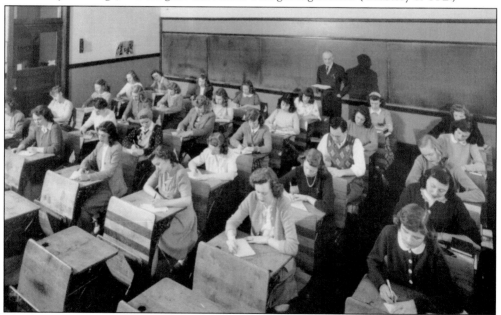

1947 Classroom. Paul Prentice, a science teacher in 1947, who later went on to become the head of the science department, stands in his fifth-period science class. This image shows the old wooden desks connected together. Student styles continue to change throughout the years. In 1947, there was a dress code requiring girls to wear dresses. Girls were not allowed to wear pants until the 1970s. (Courtesy of TPL-13922.)

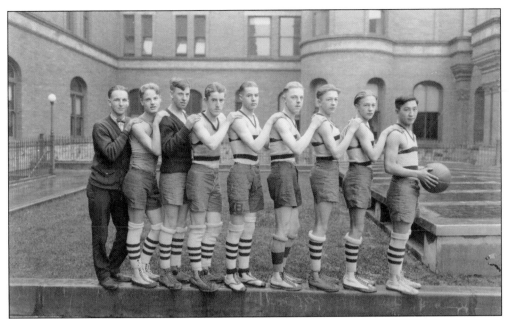

1925 Boys Basketball. Sports have always played a significant role at Stadium High School. Sports help develop teamwork, self confidence, and school spirit. Basketball has been one of the long traditions of boy's sports. This 1925 basketball team features, from left to right, Coach L. Lynn Deal, unidentified, Chuck Poole, Howie Sheldon, "Swede" Jurich, Irvin Muri, Ernest Jones, Joseph Jandell, and team captain Hito Kada. (Courtesy of WSHS-1957.64. B11929.)

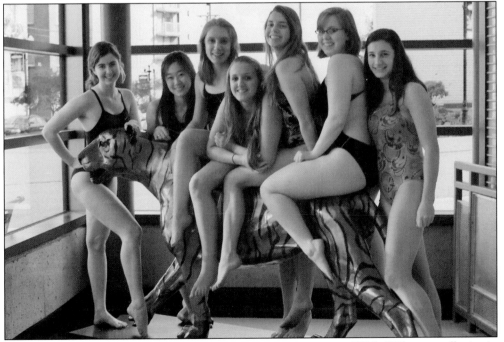

Tigers Swim? Girls had fewer opportunities to compete in sports until Title IX became effective in 1972. SHS swim team seniors, class of 2010, are, from left to right, Shannon Tebbetts, Annie Jeong, June Landenburger, Mariah Martel, Kelsey Longrie, Katie Ryesmus, and Gwen Crabtree. (Courtesy of SHS.)

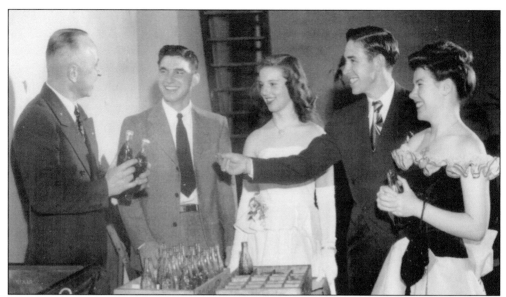

SOCIAL ACTIVITIES. The Annual Senior Ball is a formal event and a memorable rite of passage for many. The theme of the 1947 Stadium High School Senior Ball was "Orchids in the Moonlight," and the ball was held in the school gym. Featured, from left to right, are Ralph Christie, Bert Fisher, Marilyn Knapp, Robert Fife, and Ann Skupen. (Courtesy of TPL.)

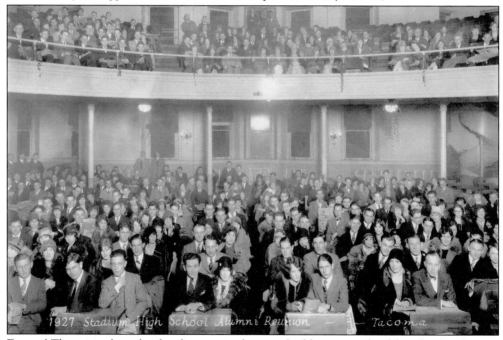

ESCAPE! The original two-level auditorium in the main building was utilized for school gatherings such as this 1927 class reunion. The original auditorium had a spiral slide-pole fire escape, which can be seen to the right. Graduates reminisce about sending coins and marbles down the slide during study hall. It made quite a racket, which flustered the librarian, and added to the amusement! Others recall sending one of their favorite industrial art teachers, Mr. Veach, down the fire-escape slide! (Courtesy of Thomas Stenger.)

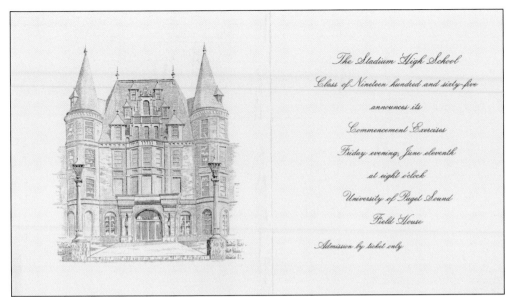

ANNOUNCEMENT. High school graduation is a significant milestone for students, parents, and teachers. Darrol Smith's 1965 graduation announcement represents one of 18 people spanning four generations from the same household to have graduated from Stadium High School (pages 54–55). Nearly 50,000 students have graduated from Stadium High School since 1906: The school's first graduating class had 55 graduates; the class of 2010 had 304. (Courtesy of Smith-Barr.)

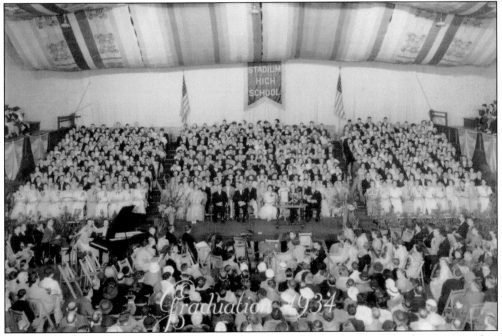

GRADUATION CEREMONY. As the graduating classes grew larger, the venue for the ceremony has changed over time. The graduation ceremony of the class of 1934 took place in the Washington National Guard Armory located at 714 South Eleventh St. Perhaps due to the Depression, the 1934 class did not wear the traditional cap and gown. The girls wore floor length formals, and the boys wore suits and ties. (Courtesy of TPL.)

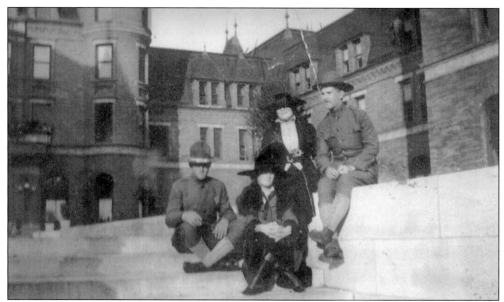

WORLD WAR I GRADUATES. Stadium High School became a national landmark the day it opened. Tacomans were proud of this unique school, described as a "castle." World War I veteran George Keniston (left) always had special pride in his voice when he spoke of Stadium High School. This 1916 image also features Violet E. Lewis, Gladys Lewis, and Arthur Bach. Both of these couples married, and their great-grandchildren are Stadium High graduates. (Courtesy of Weaver-Keniston.)

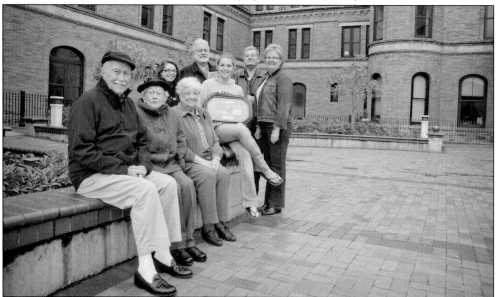

MULTI-GENERATIONAL. It is not uncommon in the Stadium District to have multiple generations of graduates from this magnificent school. Representing a family with five generations, over a century of graduates with many fond memories of "The Brown Castle," are from left to right: (first row, sitting) Robert Weaver (1948), Eleanor (Weaver) Farr (1938), Kathleen (Barr) Smith (1936), and Amberose Longrie (2014) holding the picture of her great-grandfather George Keniston (1914); (second row, standing) Kelsey Longrie (2010), Darrol Smith (1965), David Smith (1958), and Judy Smith (1966). (Courtesy of Chelle Nicole Photography.)

Five

OLD WOMAN'S GULCH

The Puyallup tribe called Old Woman's Gulch Hud-hud-gus. It was an important seasonal fishing village; here salmon were cleaned and dried to store in baskets for the winter. When the tide went out, shellfish were gathered and dried.

Herbert Hunt reports that Job Carr built a log cabin at the mouth of Hud-hud-gus for General McCarver and his family when they first arrived in Tacoma in 1868. This beach site, and the gulch behind it, was soon referred to as McCarver's Gulch. As time passed, the area developed as the NPRR coal bunkers and wharfs. As early as 1885, according to the City Directory for that year, this area also contained a community of fishermen. It transitioned into a place for the poor widows of fisherman who had no other place to live but in shanties in the gulch. These new residents gave the gulch the new name "Old Woman's Gulch."

Architect Frederick Heath wrote in 1910, "Every in-coming tide lapped up among a tangle of underbrush and fir logs. There with their shanties clinging to the steep banks of the gulch lived a number of old women, widows of dead longshoremen. Right on the brink of this unsightly hole stood the high school, an imposing French-chateau structure. It was the utter incongruity of the two extremes, palace and jungle that suggested making of an athletic field in the gulch."

The public embraced his idea. With financing in place, Heath borrowed construction techniques from the mining industry using large quantities of water under pressure to sluice the soils away, which were deposited on the tidelands below.

Stadium Bowl held opening ceremonies on June 10, 1910, to a standing-room-only crowd of 65,000. The two-day festival involved over 16,000 students from all Tacoma public schools and included many special events, including an evening cavalry equestrian exhibition sponsored by the Washington National Guard, Troop B. Over the past century, Tacoma's Stadium Bowl has hosted three presidents and many celebrities. Millions of spectators have filled the stands to enjoy entertainment of all sorts. The legacy of this exceptional place of beauty and important public gathering place continues today at this "Eighth Wonder of the World—Tacoma's Stadium Bowl."

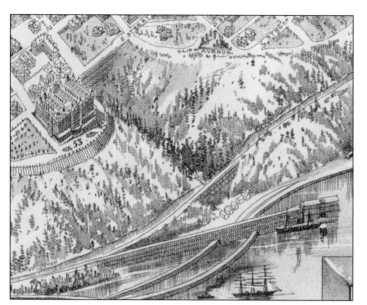

HUD-HUD-GUS TO McCARVER'S GULCH. Hud-hud-gus was a Puyallup seasonal fishing village. General McCarver lived here in 1868 and recorded, "I can frequently throw out my bare hands and gather from the bay enough smelt to supply a camp of fifty men . . . making great hauls . . . 2,000 fine salmon in one seining." There was a beach trail that followed the edge of the bluff to Blackwell's Point. (Courtesy of WSHS-MAP1893.)

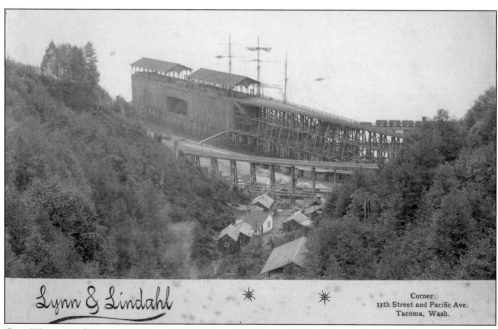

Lynn & Lindahl

Corner
11th Street and Pacific Ave.
Tacoma, Wash.

OLD WOMAN'S GULCH. McCarver's Gulch gradually transitioned into shanties where poor widows lived, Old Woman's Gulch. Heath portrayed it as "utter incongruity of the two extremes, palace [Brown Castle] and jungle." When the contractors went to burn the shanties, one widow became hysterical and remained in her hut until the water, mud, and stones poured into her back door. No provisions were made for the poor displaced widows. (Courtesy of Marc Blau.)

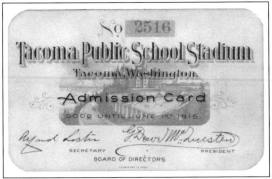

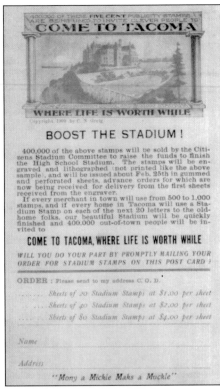

BOOST THE STADIUM. P. A. Perkins as chairman formed a Stadium Subscription Committee. In 1909, with the enthusiastic help of SHS students, over 400,000 of these 5¢ publicity stamps (right) were sent out to support financing of the proposed new Stadium Bowl. Public subscriptions helped finance the Bowl. Contributors were entitled to a free-admission pass (above) to the first five years of events. The estimated cost for the construction for the proposed stadium was $159,000. (Above courtesy of Marc Blau, right courtesy of TPL-Thomas Stenger.)

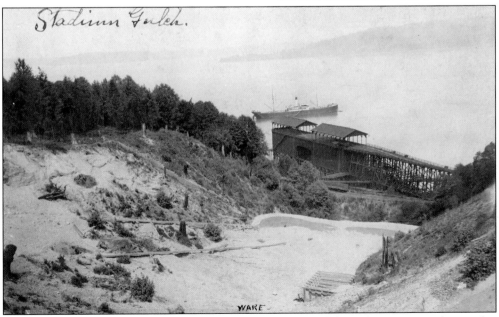

SLUICING. Sluicing of Hud-hud-gus began in 1909. Borrowed from the mining industry, this technique utilized large volumes of high-pressure water to wash over 185,000 cubic yards of earth to the shore 250 feet below. Environmental impacts, social equity, and environmental justice were not part of the equation at this time. Prime habitat for salmon and housing for the poor were destroyed. (Courtesy of Marc Blau.)

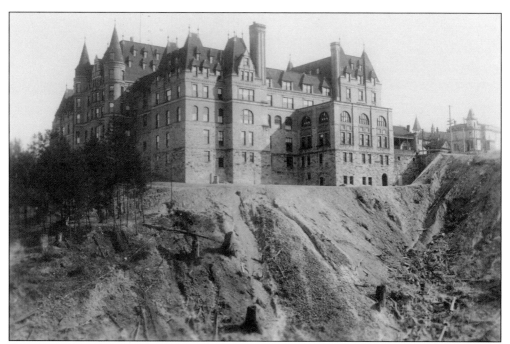

CREATING THE BOWL. All remaining vegetation had to be removed from the steep unstable slopes. Cleared tree trunks can be seen on the north side of the Brown Castle. Several springs were found, which produced a considerable flow of water, and were drained away in large pipes. The proposed dimensions of the horseshoe-shaped bowl were 480 feet long, 250 feet wide at its narrowest, and 390 feet at its widest. (Courtesy of Marc Blau.)

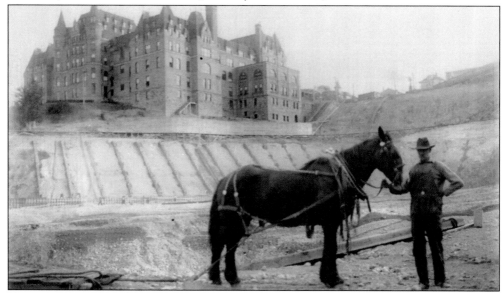

HORSE POWER. Old-fashioned horse power was used extensively in the shaping of the Stadium Bowl. By September of 1909, stadium-seating forms could be seen on the prepared slopes once covered with trees and brush. Over 4,500 cubic yards of cement was poured, and 148 tons of structural steel was used to construct 6.42 miles of concrete seats that were 31 tiers high with a seating capacity of 25,000 people. (Courtesy of TPL.)

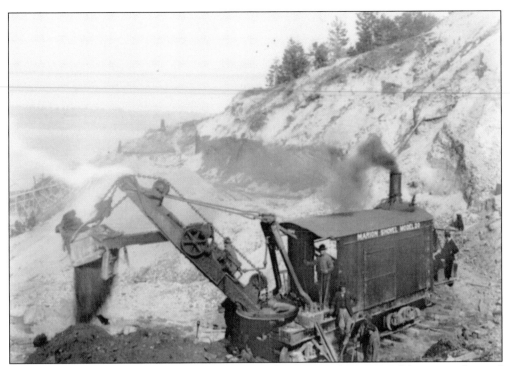

DONKEY POWER. This May 1909 image illustrates the most modern state-of-the-art mechanical donkey used during the extensive excavation that transformed Old Woman's Gulch into a mammoth horseshoe-shaped stadium. (Courtesy of TPL.)

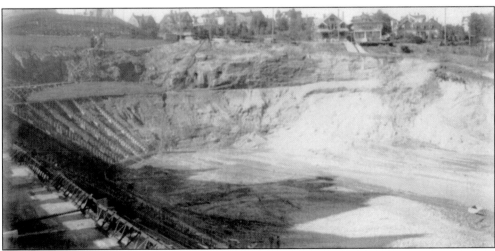

HORSESHOE, WEST. This April 1909 picture, looking west from the bowl, shows the homes along E Street and Stadium Way. North E Street, which was 100 feet above the field, was closed in 1987, and the homes, from right to left, that once belonged to Hewitt, Griggs, Wagner, Metzler, Huth, Morrill, and Hamilton have since been demolished. Some were replaced with parking lots and high-rise condos, while others remain stairs to nowhere (page 123). (Courtesy of TPL.)

HORSESHOE, EAST. The entire stadium occupies four acres. Two-thirds of the circular part of the Stadium stands on pilings, some of which are driven 80 feet deep. There is a 2,000-foot-long retaining wall reinforced with 55 tons of steel. Tacoma's great stadium was completed in 1910 at a cost of $159,638.46. (Courtesy of TPL.)

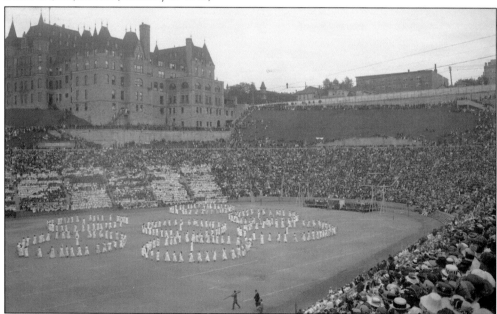

OPENING CELEBRATION. Thousands of school students participated in the opening ceremonies. "The Stadium March and Two Step" was composed by Paul Engel for the occasion. A special stadium song, "Tacoma The Rose of the West" was written by Tacoma's Carolyn Shaw Rice and Ophelia Baker Opie, and was sung by 1,000 voices at the dedication of Tacoma's great bowl. Spectators were estimated at over 65,000. (Courtesy of WSHS-1943.42.32708.)

STADIUM CROWDS. Tacoma's Stadium Bowl, which is located in the heart of the city and only nine blocks from the main business district, was an overwhelming success. In 1910, four streetcar lines served the area. Each year, thousands of spectators gathered at Stadium Bowl for the annual "Stadium Day." Football games, track and field meets, fireworks for the Fourth of July, and other events have attracted hundreds of thousands of spectators over the years. (Courtesy of WSHS-1943.42.32711.)

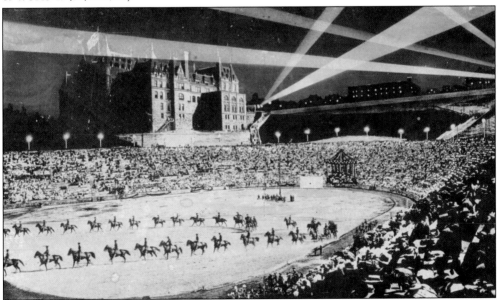

TROOP B. Magnificent Tacoma Stadium Bowl opened with a two-day opening ceremony on June 10, 1910. The famous Washington National Guard Troop B, featuring excellent equestrian skills and feats, performed a special evening presentation. General Ashton formed Troop B in 1889. Capt. Everett Griggs (page 44) lead Troop B in 1910. Troop B and Woodbrook Hunt Club drew many members from Stadium High School, the residential district, and region. (Courtesy of WSHS-Tac-Sch-SHS-25.)

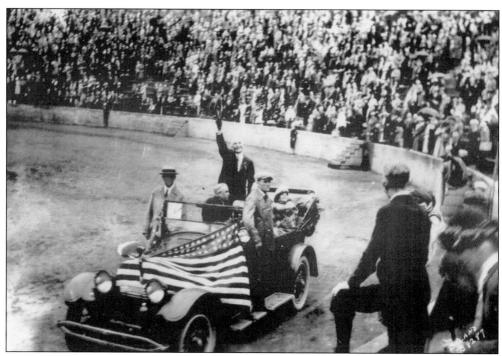

PRESIDENT HARDING. With a cheering crowd of 25,000 waving American flags, Pres. Warren G. Harding and his wife visited Tacoma's Stadium Bowl on July 5, 1921. Tacoma was shocked at the news of President Harding's sudden death from a heart attack on August 2, 1921, in San Francisco. A large crowd overflowed the stadium with bowed heads as they listened to a prayer for the president they had cheered less than a month before. (Courtesy of TPL-36768.)

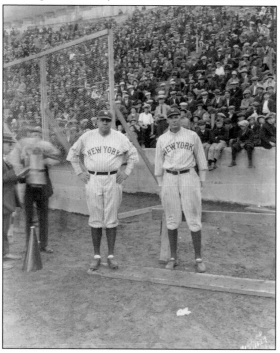

BABE RUTH. New York Yankees Babe Ruth and Bob Meusel made a special appearance at Stadium Bowl in October of 1924. Ruth played with the Tacoma All-Stars and Meusel played with the Timber Leaguers. Anticipation was running high when Ruth came up to bat in the ninth inning, with the All-Stars trailing the Timber Leaguers. The Bambino went down swinging but that did not dampen Tacoma's love for the baseball icon. Ruth was invited back in 1926 for a week of appearances. (Courtesy of WSHS-1957.64.B11179.)

BOB HOPE. Stadium Bowl cheered entertainer Bob Hope at a special two-and-a-half hour performance in June of 1946. Hope entertained troops during World War II, the Korean War, and the Vietnam War. Other famous entertainers to perform at Stadium Bowl include John Philip Sousa and Blood, Sweat and Tears, who played for the 2006 Centennial Celebration, which set a record in *The Guinness Book of World Records* for the most-attended high school reunion. (Courtesy of TPL.)

PRES. WOODROW WILSON. Crowds cheered President Wilson on September 18, 1919, upon his arrival at Tacoma's Stadium Bowl. A large percentage of Stadium High School students were shifted to his namesake, Woodrow Wilson High School, in the fall of 1958. One senior included in this transfer was Stadium's internationally renowned glass artist Dale Chihuly. The class of 1959 has joint reunions due to this student-body split. (Courtesy of USLOC-LC-USZ62-106648.)

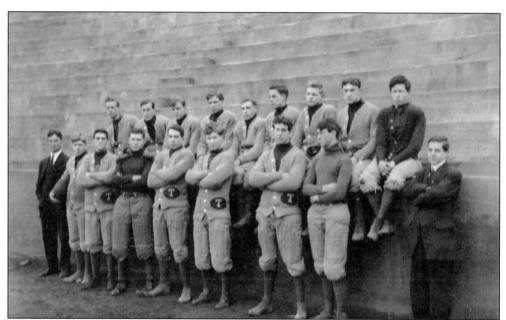

TACOMA (STADIUM) HIGH 1910 FOOTBALL TEAM. This team picture was taken against the brand-new stadium seats in 1910. Included is Fredrick C. Miller Jr., sixth from the left in the front row. He was the son of Dr. Fred Miller and grew up at 618 North G St. (pages 52–53). Fredrick became an insurance inspector. The 1910 Stadium High School football team record was five wins, two losses, and one tie. The field was dirt, mud, and grass and games were played to full-house crowds. (Courtesy of Mary Bowlby.)

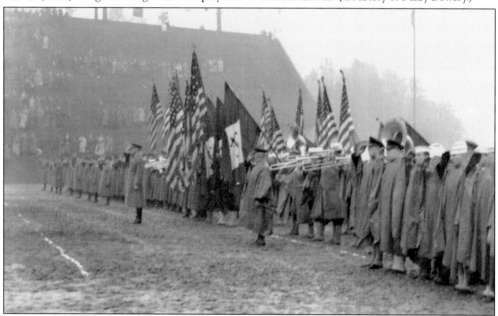

ARMY-NAVY FOOTBALL TRADITION. Soldiers, sailors, and marines from Fort Lewis Military Base and Bremerton Naval Shipyard face off against each other in Tacoma's Stadium Bowl for a charity Army-Navy football game on Armistice Day, November 11, 1935. Taps for the war dead preceded the grid conflict. A 21-gun salute closed the event. Cold rain fell throughout the day and turned the field into a sea of mud. The final score was Navy 6, Army 2. (Courtesy of TPL.)

STADIUM-LINCOLN. Fans packed the bowl to cheer their teams on at this Annual Thanksgiving-Day Football Classic. Under Coach Levinson's leadership, Stadium trampled Lincoln with a score of 19 to 7. Stadium's Tom Sisul (26), Fred Barnes (16), Bill Keyes (25), and George Emery (45) are involved in the "gang-tackle" on the muddy field. With this win, they became the 1959 City League Champions. The Tigers outplayed the Lincoln-Abes in both offense and defense. (Courtesy of Tom Sisul.)

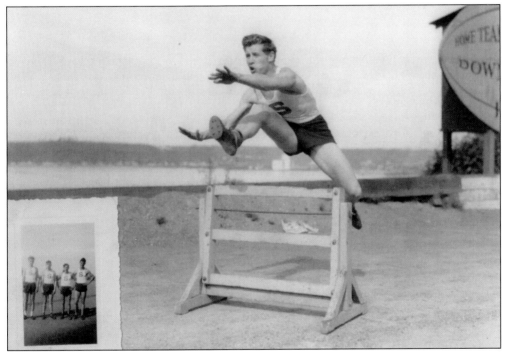

STADIUM TRACK. Ross Soper demonstrates the hurdle form he used to set the 1939 200-yard city record at 23.3 seconds. Stadium champions Soper, Gerry Bell, Frank "Hank" Clinton, Dick Clinton, and Wiseman often competed against rival Lincoln track star Dick "Floge" Keniston, who was state champion in the 220-yard dash in 1941 with a time of 21.6 seconds. These men served in the U.S. Navy during World War II and were also track and football stars at WSU and UW. Stadium graduate Herman Blix won silver in the shotput at the 1928 Olympic Games in Amsterdam. (Courtesy of TPL and Clinton family/Clintons Music House.)

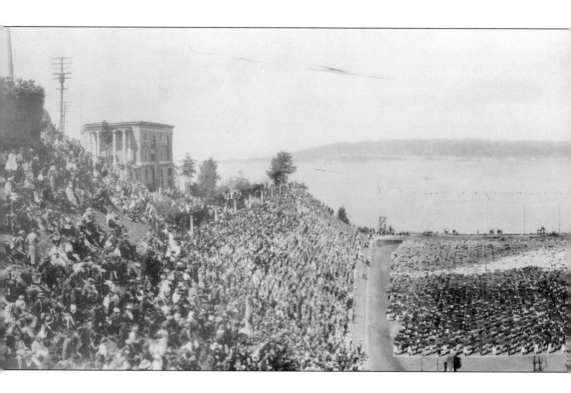

TACOMA'S STADIUM DAY. An annual tradition called "Stadium Day" lasted for over 60 years. Nearly 16,000 students annually participated in drills, music performances, and speeches. The 1922 image above shows a typical standing-room-only crowd. The Washington State Historical Society (WSHS) building is on the left, and Brown Castle is on right. Located 150 feet above the placid waters of Commencement Bay with commanding views of the Olympic and Cascade Mountains, Stadium Bowl boasted a 40-foot flag on the tallest flagpole in Washington State at 190 feet. The

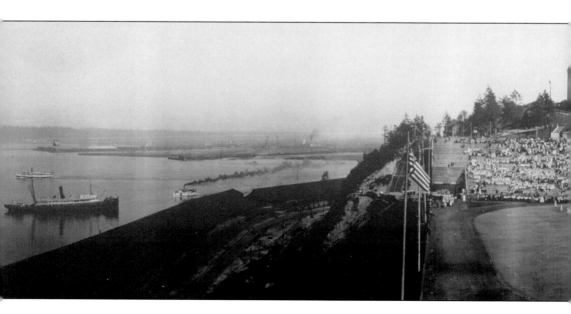

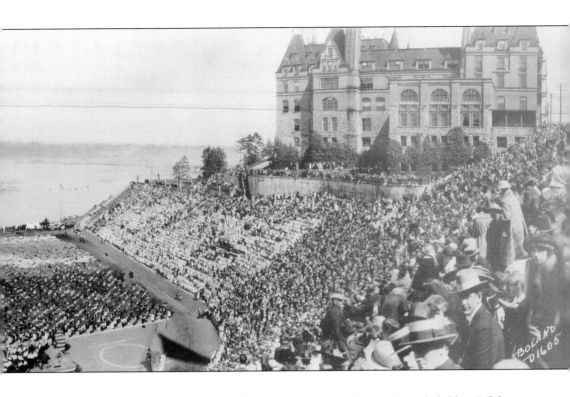

original official capacity was 23,486; Heath stated, it "seats 32,000 adults and children." Often times, overflow crowds of 40,000 were reported. Attendance that included people sitting on walls, fences, hillsides, and adjoining roads set records as high as 65,000-plus for big events. Modern capacity has been reduced to 15,000 as a result of earthquakes, chronic drainage problems, and a major sewer break, which eliminated the seating in the horseshoe. (Above courtesy of WSHS-1956.42.1, below courtesy of USLOC-LC-USZC4-4628; pan.6a27217.)

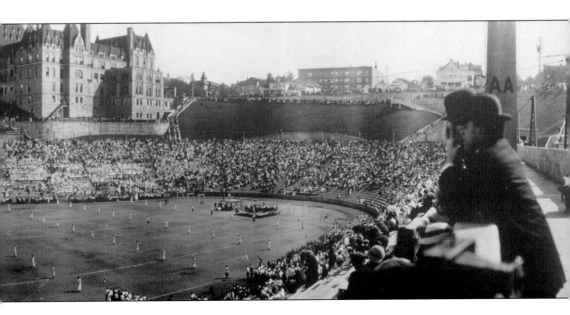

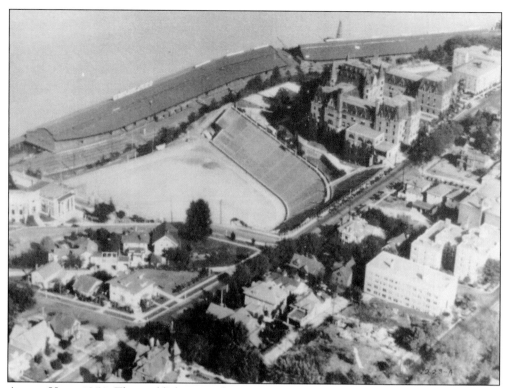

AERIAL VIEW, 1950. The world's longest wheat storage facility is seen below Stadium Bowl. Many of the homes featured in the previous chapter still exist in this image. Henry Hewitt's 1889 mansion is in the lower left corner of the photograph. To the south and across Fourth Street, the homes of the following families can be seen: Wagner, Griggs, Metzler, Huth, Hamilton, Driver, Osgood, and Morrill. The Vista del Rey condos had not yet been built. The new addition of WSHS is complete. (Courtesy of TPL-BU-11652.)

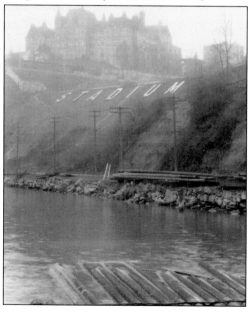

STADIUM. The Stadium brought fame to Tacoma. Lest anyone forget the name or location of Tacoma's prized Castle or Bowl, her name was brazenly written on the side of the hill for the whole world to see from sea and shore. Vegetation has since grown on the steep slope with Stadium's name; however, Tacomans will always know that the Brown Castle and Bowl are nestled high on the bluffs proudly overlooking their harbor. (Courtesy of TPL-5240.)

Six

WORK AND PLAY

During the 1887–1893 building boom, there was a parallel industrial boom that included smelters, mills, and factories that choose to locate in Tacoma. Herbert Hunt wrote, "It was wonderful to be young and affluent in Tacoma in the early 1890s. The land was lovely, and the city charged with energy. People took seriously the slogan, 'City of Destiny.' They heard purpose in the screaming saws, smelt it in the sharp scent of freshly sawed lumber. They were building a metropolis. Work was rewarded not merely with wealth, it was an act of creation, and there was time for play."

The original business district focused on the edges of today's Stadium District (St. Helens and South Sixth Street, Tacoma Avenue and North Eighth Street, and Division Avenue and I Street), which can be compared to Stadium's business district at First Street and Tacoma Avenue today. Liveries, stables, hotels, churches, schools, and saloons were the first establishments in the district located along St. Helens Avenue. The Exposition Building, a huge complex located at the head of Garfield Gulch (North Eighth Street and Tacoma Avenue), drew crowds for many special events. Grocery stores and dance studios sprung up at the confluence of Division and I. As the horse-and-buggy days transitioned to trolleys and automobiles, service stations were built to meet the neighborhood's needs. When the original Annie Wright Seminary was demolished in 1925, the site became the heart of today's Stadium Business District with signature businesses like Stadium Grocery and Titus-Will Automobile. The Gray Goose Coffee Shop and Confectionery soon changed to Ranko's Rexall Drug, the oldest family-owned business in the district. Houses that once lined Tacoma Avenue between Division Avenue and Second Street were demolished or converted into businesses.

Tacoma's new large industries fueled local neighborhood small business needs. It also supported the ability and desire to recreate. Churches, along with fraternal and recreational organizations, played a significant role in bringing strangers together in this new city. Tacoma's Stadium-Seminary District residents worked hard and played hard. They were instrumental in establishing many organizations in the 1890s that are still active or formed the roots of leisure activities we still enjoy today.

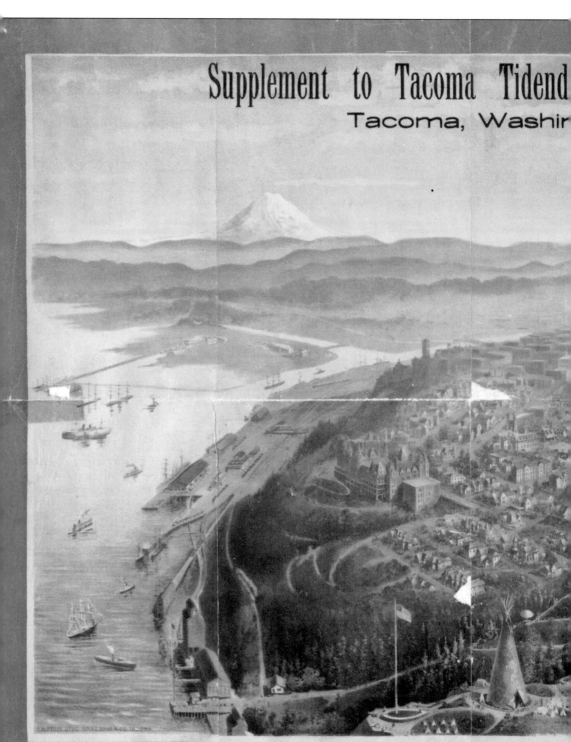

Supplement to Tacoma Tidend

Tacoma, Washir

BIRD'S-EYE VIEW NORTHWEST

NORTHWEST INTERSTATE FAIR.
The *Tacoma Sunday Ledger* on October 7, 1894, featured this bird's-eye view of the Northwest Interstate Fair, extolling Henry Bucey as the person responsible for organizing and publicizing this magnificent agricultural fair. "Engineer Fred G. Plummer had charge of laying out the grounds and is responsible for the beautiful winding paths, rustic bridges, and picturesque arbors in the ravine . . . A clearing-bee transformed a mass of tangled underbrush and trees on the site of the fairgrounds into a beautiful park." The fair ran from May to November 1894. Ashton Hill, owned by General Ashton, can be seen in the lower-left corner (pages 100, 125). The Fair covered the entire area we know today as Annie Wright Seminary, Garfield Gulch, and the Tacoma Lawn Tennis Club. It featured a Native American village, an agricultural building, and a cyclorama, among many other features. (Courtesy of WSHS-2009.0.482.)

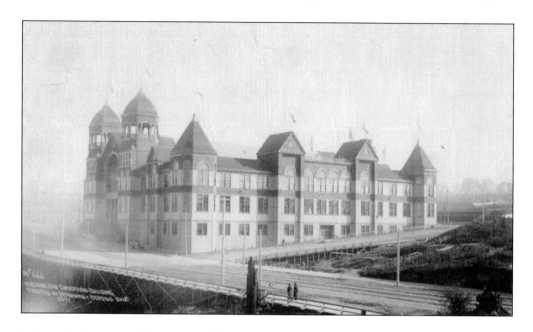

WESTERN WASHINGTON INDUSTRIAL EXHIBITION BUILDING. Rain and muddy roads did not deter large crowds for the grand opening of the Exhibition Building, the largest wood-frame building on the West Coast, on September 10, 1891. Billed as one of the most brilliant affairs in Tacoma's history, Governor Elisha P. Ferry read a congratulatory letter from Pres. Benjamin Harrison. A 25-piece orchestra played. Displays of grains, fruits, and vegetables were sent to the 1893 Chicago World's Fair. The old elevated Tacoma Avenue Bridge can be seen above. Below is a rare interior image of the Exhibition Building. The building hosted Rose Carnival Balls, a roller-skating rink, a polo hall, equestrian horse shows, and many musical concerts. The Exhibition Building was located on Tacoma Avenue between North Seventh and North Ninth Streets, across from today's Annie Wright School (AWS). (Above courtesy of TPL, below courtesy of WSHS.)

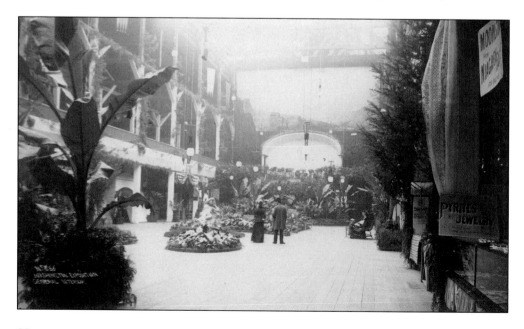

FIRE! Fire destroyed the Exhibition Building on September 20, 1898. The wooden building, owned by Tacoma Land Company, carried insurance. *The Daily Ledger* The alarm was turned in by a girl living directly across G Street who says she first saw the flames in the northwest corner of the building at about 2 The building was engulfed in flames when the horse-drawn fire arrived. (Courtesy of TPL.)

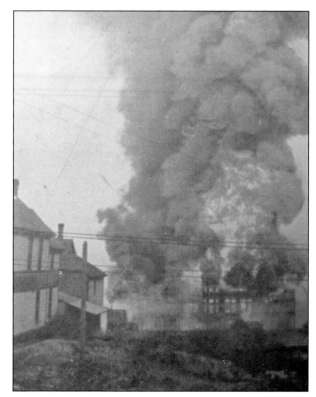

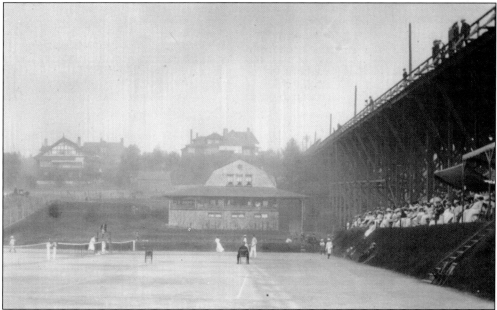

NEW TENNIS CLUB. The old Tacoma Avenue Bridge, which was removed in 1911 when Tacoma Avenue was re-aligned (page 100), is seen to the right in this 1910 picture taken at the current new Tacoma Lawn Tennis Club (TLTC). The old TLTC (page 109) was formed in 1890 by George Browne and was located on First Street and Division Avenue. Women are shown playing tennis in formal long dress. (Courtesy of TPL/TLTC.)

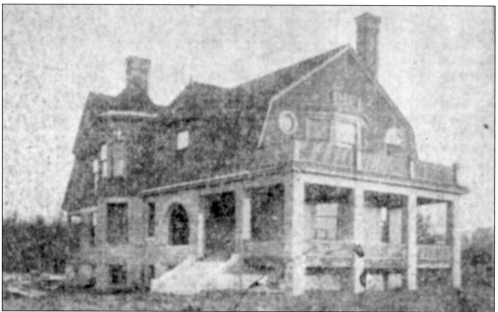

ASHTON HILL. A Canadian, orphaned at age two, Gen. James M. Ashton studied law but was lured to the "Wild West" and became a superb horseman. He arrived in Tacoma in 1882 as a legal counsel for the NPRR. Captain of Washington National Guard, Troop B (pages 87, 125), and closely tied to the future Woodbrook Hunt Club, Ashton was also a member of the Masonic Knights Templar. Above, his house and gardens on North Tenth Street overlooked Commencement Bay behind the modern Annie Wright Seminary. His home was destroyed with the re-grading of Tacoma Avenue. Over 35,000 cubic yards of Ashton's Hill were removed to fill the area for the TLTC. The aerial view below shows the re-aligned Tacoma Avenue with the wooden-trestle bridge removed, the new Annie Wright School built in 1924, and the old Aquinas School (lower right). (Above courtesy of TDL, below courtesy of M. E. Donovan.)

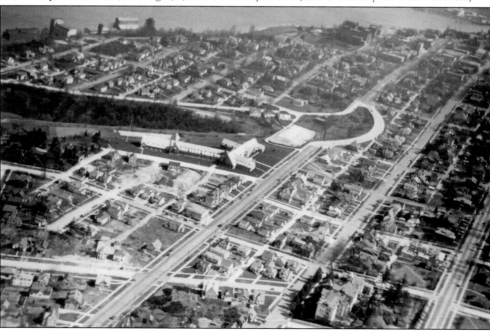

STADIUM'S BUSINESS DISTRICT. After the original Annie Wright Seminary moved from Tacoma Avenue between First Street and Division Avenue to its current location at North Tenth Street in 1924, the vacated triangular parcel (left center) fronting Tacoma Avenue became the new nucleus of Tacoma's Stadium Business District. This 1958 aerial photo is a bird's-eye view of the business district. (Courtesy of TPL.)

STADIUM CONFECTIONERY. The northeast corner of Tacoma Avenue and First Street has always been a popular venue for Stadium High School students to hang out after school. This c. 1923 image shows a Pacific Brewery delivery truck (page 39) parked outside the Stadium Confectionery and Grocery Store. Several Victorian homes, which no longer exist today, can be seen between the confectionery and Stadium High School. (Courtesy of Thomas Stenger.)

RANKO'S PHARMACY. For nearly 75 years, the family-run Ranko's Pharmacy has been serving Tacoma's Stadium District at 101 North Tacoma Ave. Founded originally by George and Katharine Ranko in 1939, it is now co-owned by the next generation, Deanna, Greg, and Elizabeth Ranko. Its customer service, pharmacy, gift shop, and post office have all meet the needs of customers for decades. Ranko's used to have a soda fountain and jukebox, which were popular with Stadium students after school. Former Stadium students reminisce about drinking cherry cokes and jitterbugging to the jukebox in the corner (below). Deanna Ranko, Stadium class of 1962, served as Stadium Business District president for a time and has long been active in the community. (Both courtesy of Ranko's.)

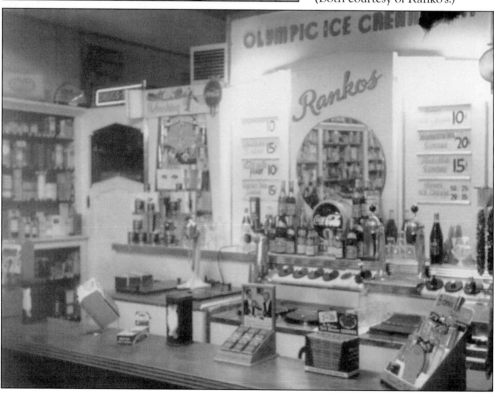

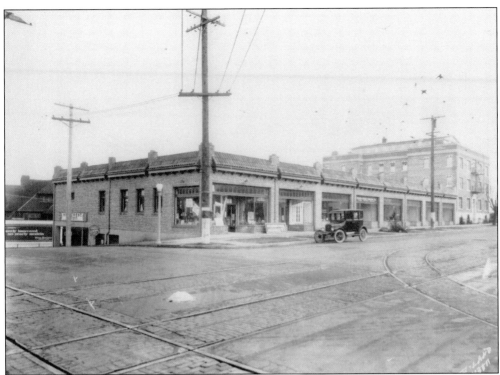

BEFORE THE HARVESTER.
The building located on the southeast corner of North Tacoma Avenue and First Street has long been associated with food. Stadium Market, IGA grocery store, Scotty's Café, and now The Harvester have served many meals to Stadium District residents and visitors. The image above was taken in 1925. In September of that year, Hillcrest Garage and Tacoma Wicker Company both opened in the building. In 1927, the KVI Radio Station operated from here. Shown at right in 1954, Beverly "Bev" Loska is dressed in a tidy white cap, advertising some of the first fast food in the area, Scotty's Tray Vittles. Scotty's Café was owned by Joseph W. Carbone. Today The Harvester is owned by Tim and Lorie Tweten. (Both courtesy of TPL.)

HORSES TO AUTOMOBILES. The horse-and-buggy days were gradually replaced by the automobile, resulting in the transition of livery stables to service stations. The 1928 image above shows Union Oil Service Station at 601 North First St., where Columbia Bank is today. Ball's Service Station at 116 Tacoma Ave. is a three-generation family run business, providing automotive service to customers near and far. (Both courtesy of TPL.)

TEA ROOM AND HAIR SALON. The Tudor Tea Room and Delicatessen occupied the building at 16 North Tacoma Ave. The building still stands and has been occupied by Prendergast Flowers, American Automobile Association, and Franco the Tailor, which is still active today. Beauty salons have long been a signature business fixture in the Stadium District. In the 1958 image below, Miss Helene was carefully blow-drying Bonnie Lee's hair at Jimmie's House of Beauty at 118 North Tacoma Ave., which was owned by James Crowley. Other beauty shops that have been in the area include Marty's, Parvenue Hair Design, Metro Hair Cuts, Angelo Mendi Boutique Saloon, and North Eye Hair. (Both courtesy of TPL.)

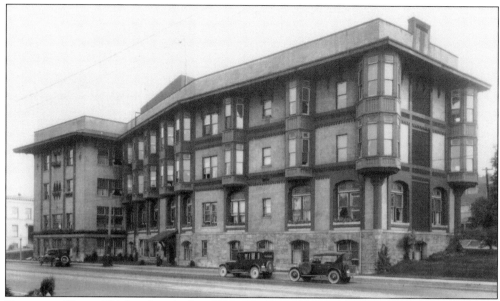

ROCHESTER HOTEL. This hotel was built in 1888 and renamed the Bonneville Hotel in 1906. Clinton P. Ferry, "The Duke of Tacoma," lived here. He honeymooned in France; however, his new wife apparently learned more than just the language from her French tutor, as she stayed in France and never came home. Upon his return home in 1891, he donated two large lion and dancing maiden statues to Wright Park. The Bonneville (Rochester) Hotel was demolished in 1966 and its site is now a parking lot for the Masonic Lodge and Temple Theater (Landmark Convention Center). (Courtesy of TPL.)

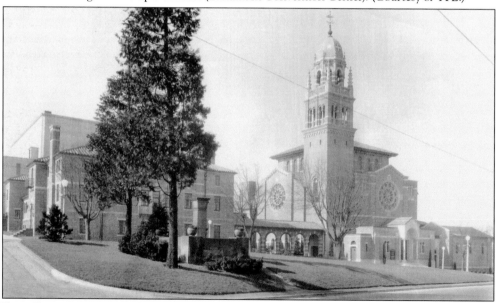

FIRST PRESBYTERIAN. Local architects Sutton, Whitney, and Dugan, along with national church architects Cram-Ferguson from Boston, designed First Presbyterian Church at 20 Tacoma Ave. South. A fine example of Romanesque architecture, its cornerstone was laid in 1924, and its doors opened in 1925. Norton Memorial Park is seen in the foreground, which was established in honor of Percy Dunbar Norton, a pioneer businessman associated with St. Paul & Tacoma Lumber Company, who died in office as city council president in 1900. (Courtesy of TPL.)

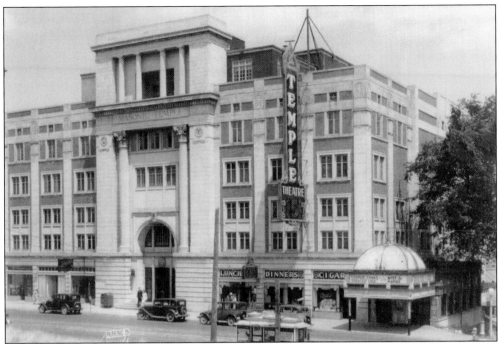

MASONIC TEMPLE. Polk Directories listed the Masonic Temple under "Secret and Benevolent Societies." Masons played an important role in Tacoma. Pres. Theodore Roosevelt made his first visit to Tacoma in 1903 to participate in the cornerstone-laying ritual for the Masonic Temple downtown. Located at 47 St. Helens Ave., the new Masonic Temple opened in 1927. Adjoining is the Temple Theater, originally called the Heilig Theater. With roots dating to the Crusades, Freemasonry is a male-only fraternal organization, which was established to pass construction secrets from generation to generation. Many national leaders and early prominent Tacoma leaders were Freemasons. This building also houses a Masonic museum. The cornerstone-laying ritual (below) brought many dignitaries to Tacoma over the past 125 years. (Above courtesy of TPL, below courtesy of WSHS-1943.42.61526.)

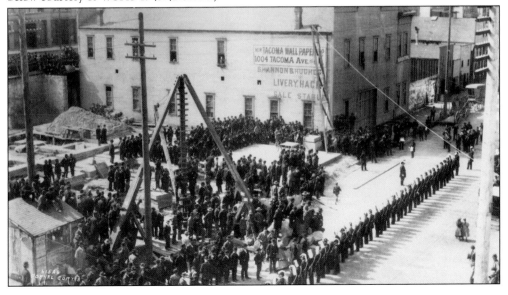

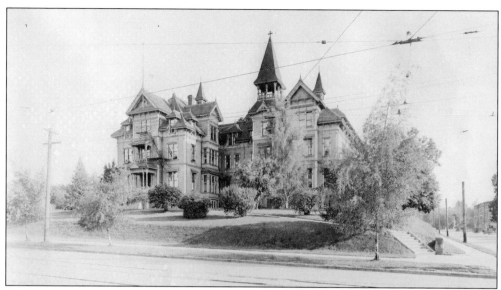

STADIUM THRIFTWAY. The original Annie Wright Seminary faced Tacoma Avenue (above) and occupied the triangular parcel now occupied by Stadium Thriftway, Titus-Will, and the many businesses between Division Avenue and First Street. The Stadium Market is seen below c. 1931 looking very similar to the Stadium Thriftway of today. The Stadium Market is located in Allen Motor Company Annex, and Packard Tacoma Company is in the same building. Some of the other retail businesses that have rented space include: Van De Kamp's Bakery, Greens Dairy and Poultry, Stadium Florist, Frank's Fruit and Produce, Stadium Fruit and Produce, Stadium Coffee Shop, and Stadium Meat Market. The original Annie Wright Seminary cornerstone, laid in 1884, along with its time capsule, has never been recovered. (Above courtesy of WSHS-2010.0.55, below courtesy of TPL.)

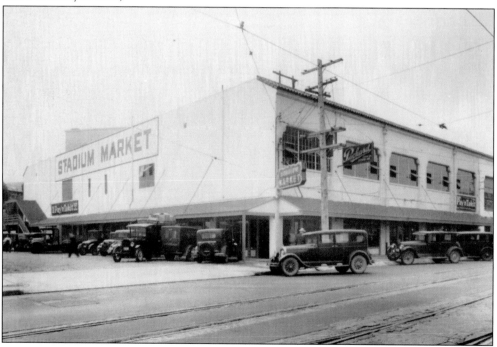

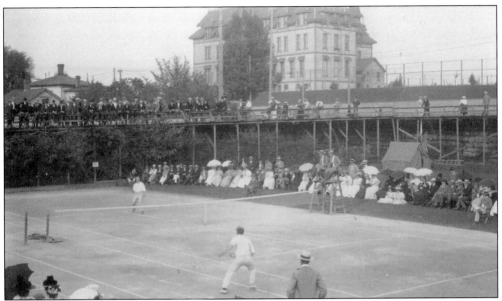

OLD TENNIS CLUB AND TITUS-WILL. The above photograph of the Tacoma Lawn Tennis Club at First and G Streets was taken around 1890 looking south towards Wright Park. The original Annie Wright Seminary is in the background. The Tacoma Lawn Tennis Club moved to its current location in 1905 (page 99). Below is a 1926 Polk Directory Advertisement for Allen Motor Company, which was located at the Annie Wright Seminary site (pages 26, 108). Today the old TLTC location is occupied by the Titus-Will used car lot. Next to this site are the Woodstock Apartments, originally called the Tennis Court Apartments, which were built in 1905 by Thomas E. Ripley, author of *Green Timber* and vice president of Wheeler-Osgood Door/Sash Manufacturing Company, once the world's largest manufacturer of doors. (Above courtesy of TLTC, below courtesy of TPL.)

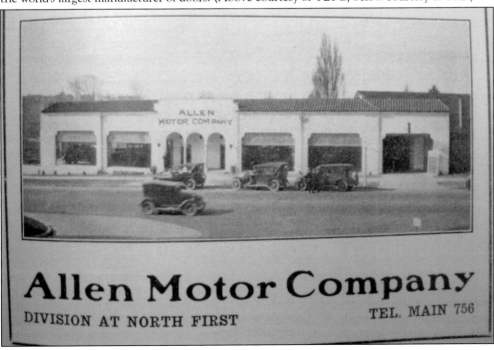

Allen Motor Company

DIVISION AT NORTH FIRST TEL. MAIN 756

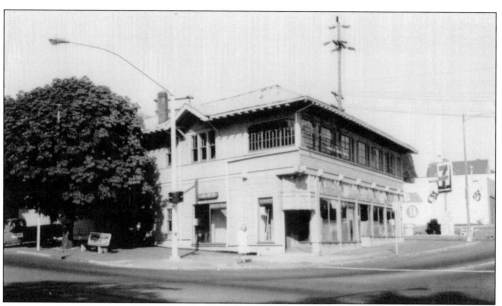

DIVISION AND I STREET. Built in 1908, Roberts Brothers Grocery occupied the historic wooden building at 124 I St. on the northwest corner of Division and I. Sloan's Dancing Academy and Jan Collum Dance Studios occupied the upper floors. Many children learned to dance here, and many dance contests were held in this studio. Today this building is occupied by Subway Sandwiches and TCF Architect. Murray Morgan's father was minister of the Park Universalist Church, originally located at this site from 1892 to 1907, but the building was demolished to build a new church at Division Avenue and J Street. (Above courtesy of TPL, below courtesy of Faye Langston/Iris Bryan.)

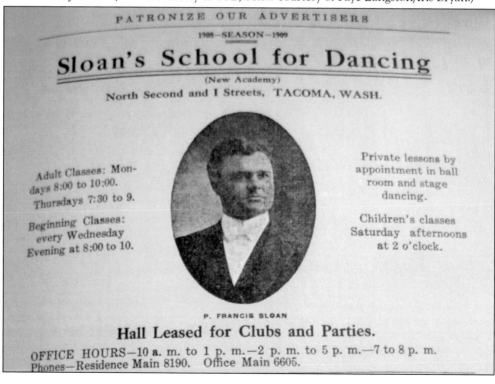

WAHLGREN'S FLORIST. Located on the corner of Second Street and North Yakima Avenue was another family owned business, Wahlgren's Florists. Prior to opening the florist shop, the Wahlgren's operated a miniature golf course at this site. Many neighborhood children loved playing miniature golf here. Wahlgren's opened in 1931 and operated until 1995. The building is currently utilized as an architectural office. (Courtesy of TPL.)

PARKWAY TAVERN. A local neighborhood tavern, once common and now a rarity, 313 North I St. has operated as a commercial business since the original Colonial-style home from 1885 was demolished and the current building was built in 1935. It was initially a delicatessen and later a pub. The current owner and history buff Jeff Fraychineaud has historical pictures and information on the walls regarding Tacoma's breweries and local Stadium District historical trivia. (Courtesy of Amberose Longrie.)

WASHINGTON STABLES. Prior to the appearance of automobiles, St. Helens Avenue was the location of several livery and boarding stables. Boardman Stables was listed at 409 St. Helens in 1890; Tacoma Carriage and Baggage Transfer Company occupied a new three-story facility at 607–609 St. Helens in 1905; and Washington Stables was located at 411 St. Helens in 1912. Livery stables were essential to move goods and people. (Courtesy of TPL.)

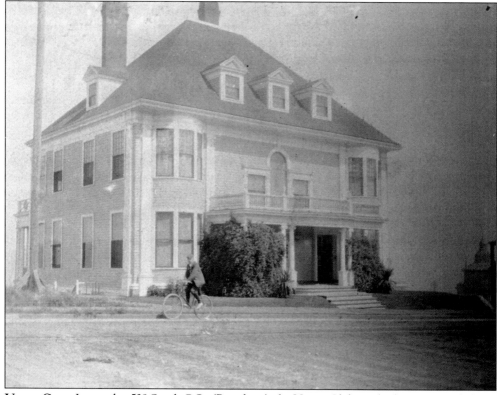

UNION CLUB. Located at 539 South C St. (Broadway), the Union Club was built in 1888 and played a vital business role in Tacoma's Stadium Business District for over a century. The Union Club was established as a place for prominent businessmen to meet to discuss business opportunities and socialize. A daily stop at the Union Club was a requirement on every businessman's schedule. (Courtesy of WSHS-1994.91.1.43.)

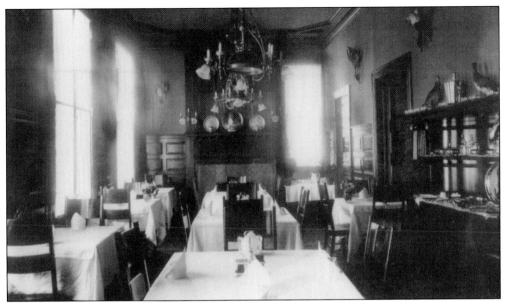

FINE DINING, CIGARS, AND POOL TABLE. The Union Club provided white linen tablecloths for its silk top-hat crowd. It also had pool tables, bowling alleys, and other amenities for the male-only business club. Murray Morgan (SHS 1933) describes a typical day for Colonel Griggs (page 41): "Griggs left for the office at 8:30 a.m. usually driving his own carriage and accompanied by Hewitt (page 40)or Foster (page 48), if they happened to be in town. His favorite route was along Tacoma Avenue to St. Helens, left to Pacific, out to Twenty-third, and then right again on Holgate. This put him at his roll-top desk at 9 a.m. In the afternoon, he visited the mills and checked in at the office before going to the Union Club, where the movers and shakers of the community talked business and politics or played dominoes . . . occasionally poker." (Both courtesy of TPL.)

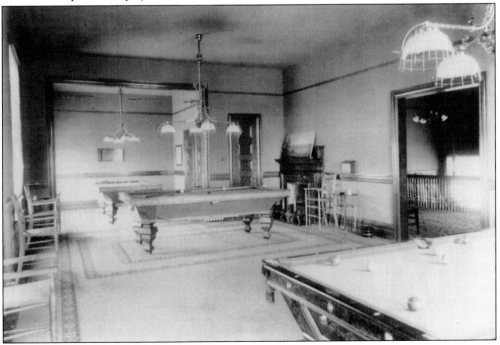

WASHINGTON STATE HISTORICAL SOCIETY. Originally named Ferry Museum, after its founder Col. Clinton Peyre Ferry, the Washington State Historical Society (WSHS) Museum was dedicated in 1911. Henry Hewitt (page 40), Robert McCormick, and John Weyerhaeuser (page 64) were key supporters of WSHS (and lived just a block away.) Alterations were made in 1915, 1938, 1942, and 1973. Today this building houses the WSHS Research Center. (Courtesy of TPL.)

DAVE AND DANDY. The WSHS has played an important educational and recreational role in the lives of many students and adults. One of the most popular and oldest exhibits is Dave and Dandy, pioneer Ezra Meeker's oxen who made several cross-country trips pulling a covered wagon. The oxen and wagon were on display in the original WSHS Museum for decades and are currently on display in the new WSHS Museum downtown. (Courtesy of WSHS-2009.0.465.4.)

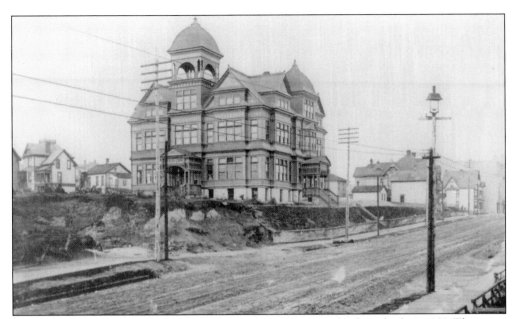

EMERSON SCHOOL. Located at 246 St. Helens Ave., Emerson School was built in 1889. The upper floor was used exclusively by the Masonic Lodge. Originally, it was the site of North School built in 1875 but was declared unsafe in 1885. Emerson School was demolished in 1920. It became the site of the Doric Hotel in the 1970s and today it is Cascade Park Vista Assisted Living facility. Note the dirt roads, wooden sidewalks, and trolley tracks. (Courtesy of TPL.)

TACOMA YACHT CLUB. In August 1890, *The Sunday Ledger* reported, "Tacoma Yacht Club is to be the center of nautical sports when the fleets of clubs yet to be organized will fleck the Sounds with snowy sails." The first Tacoma Yacht Club was on Maury Island with 54 members, including many Stadium District residents. The club moved temporarily near Ruston and has claimed its current location near Point Defiance since 1914. (Courtesy of TDL.)

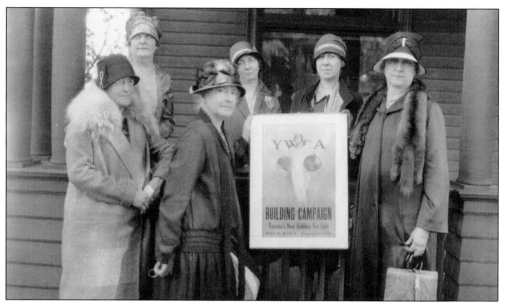

YOUNG WOMAN'S CHRISTIAN ASSOCIATION (YWCA). The YWCA purchased the Blackwell Mansion (pages 34–35) in 1923. By May of 1927, YWCA leaders announced a building fund-raiser. Pictured from left to right are the following: (first row) Daisy Warren, Mabelle Leach, and Mrs. George C. Wagner (Heartie Griggs); (second row) Mora Parkhurst, Nellie M. White, and Mabel Dodds. The YWCA provided many opportunities for Tacoma's females including hiking and swimming. Today the Blackwell Mansion serves as the YWCA shelter for battered women. (Courtesy of TPL.)

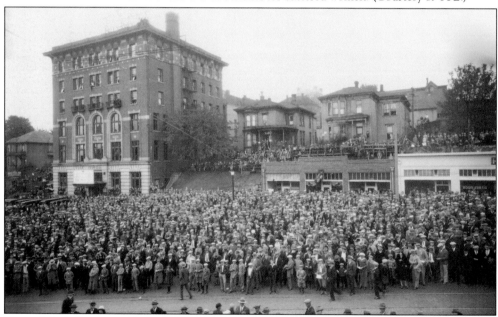

YOUNG MEN'S CHRISTIAN ASSOCIATION (YMCA). Henry Hewitt and Everett Griggs each gave $10,000 to make possible the YMCA building at St. Helens and Tacoma Avenue. Located at 714 Market St., the YMCA was dedicated in 1910 and provided opportunities for physical, social, and spiritual activities. The original YMCA building is now the Vintage Y condos. Today Tacoma-Pierce County has five YMCA branches serving over 75,000 members. (Courtesy of WSHS 1957.19.09.392.)

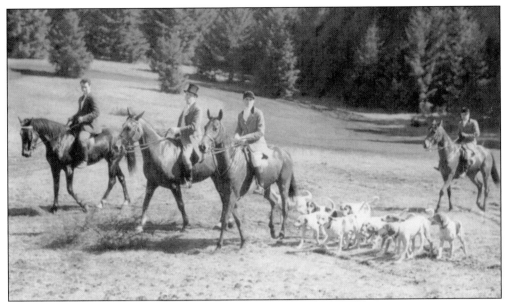

WOODBROOK HUNT CLUB. General Ashton, Nelson Bennett, Henry Hewitt, Annie Griggs, Chester Thorne, and Washington National Guard, Troop B established the Tacoma Riding Club in 1892. The club eventually became Woodbrook Hunt Club. Pictured at center, 1925 Stadium High School graduate Iris Bryan was a key leader. Today many Pacific Northwesterners enjoy riding to the hounds at Fort Lewis with master of foxhounds (MFH) Jean Brooks, joint MFH Mike Wager (SHS 1962), and whipper-in Haley Parks (AWS 2013) (page 125). (Courtesy of TPL.)

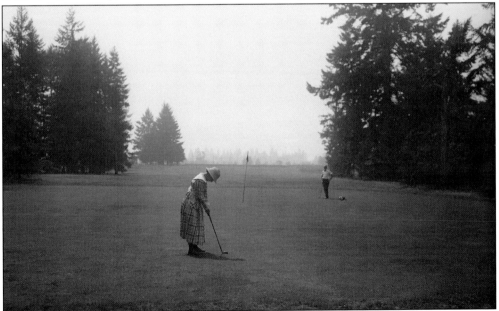

TACOMA COUNTRY AND GOLF CLUB. This image is of a 1910 golfer at the Tacoma Country and Golf Club (TCGC), which is located near the Woodbrook Hunt Club on American Lake. Alexander Baille, Charles Hurley, Herbert Griggs (page 41), L. B. Lockwood, and Dr. George Wagner established the TCGC in 1894. Today this elite organization sports an 18-hole golf course on the shores of American Lake. (Courtesy of UWSV-BAR041.)

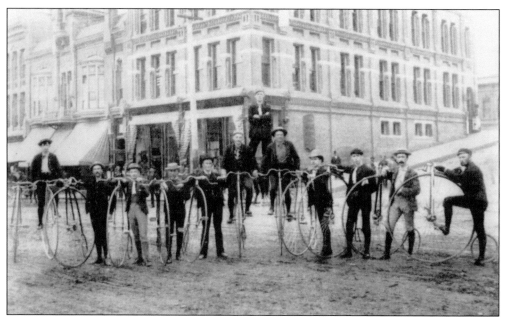

BICYCLE CLUB. F. A. Avery formed Tacoma Wheelmen's Club in the spring of 1888. Members included Isaac Anderson (page 33), W. W. Sprague, and C. V. Cooper. The safety wheel, introduced in the 1880s, made it possible for women to ride. The club rode at the G.A.R. Hall at 910 Pacific Ave., which had an indoor track. They also had weekly cross-country outings. Steven Barr (page 55) operated an early bicycle repair shop in Stadium District. (Courtesy of TPL.)

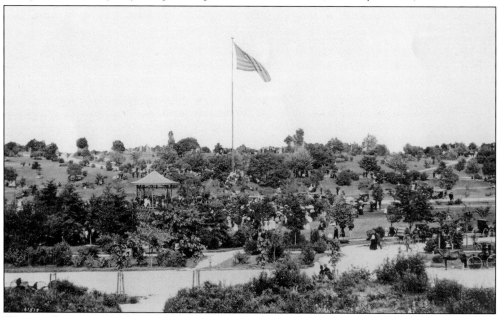

WRIGHT PARK. A Sunday was not complete without a stroll through Wright Park, which is shown in this 1890 image. Tacoma Land Company donated 27 acres provided it would always be a park. It was named after NPRR and Tacoma Land Company president Charles B. Wright. Magnificent homes can be seen on South G Street; sadly, they are now demolished. (Courtesy of WSHS-1943.42.61517.)

Seven

BACK TO THE FUTURE

If you look closely at the topography and road grades today, you can visualize the natural drainage area for Stadium-Seminary Historical District. Wright Park ponds were wetlands. While following G Street, Yakima, and Tacoma Avenue to Second Street and going east, you can imagine where the natural gulch began at Stadium Bowl. With headwaters on I and J Streets near Fifth Street, Garfield Gulch flowed through today's Annie Wright Seminary and Tacoma Lawn Tennis Club to the sound below. Old pilings in the bay mark the location of the old coal bunkers.

With a few exceptions, much of the original architectural integrity from the 1887–1893 building boom has remained unchanged. One simply has to walk, drive, or bicycle through the area to identify empty parking lots, 1960 apartment complexes, or high rises to know that the property most likely supported an exquisite 1890s-era home of an affluent family. The lure of luxury and leisure pulled the Tacoma Stadium District aristocracy to Lakewood's Lake District on Gravelly Lake, American Lake, and Steilacoom Lake during the Roaring Twenties. The stock market crash of 1929, the Great Depression, World War II, and urban renewal of the 1950s, 1960s, and 1970s sadly resulted in the loss of many historically significant homes. Fortunately, from the 1980s through the first decade of the 21st century, there has been a move away from destruction towards restoration of historical buildings and places, which included the magnificent $108 million refurbishing of Stadium High School that was completed in 2006.

The recent building boom at the beginning of the 21st century rejuvenated the restoration of historical buildings, as well as the redevelopment of properties destroyed during urban renewal in the 1950s, 1960s, and 1970s. Condominiums of 505 Broadway are prime examples of recognizing the once opulent home of Bennett Nelson that occupied this location. Grandeur, hopes, and aspirations have been captured in the details of this new high-density urban housing. The One St. Helens apartments are another good example. Plans for restoration of the Elks Temple and Union Club give hope for invigorating these grand buildings. Society's newfound optimism to restore past landmarks for the future will continue to make Tacoma's Stadium District an extraordinary place.

YORKHEIMER RESIDENCE INTERIOR.
One of Tacoma's finest mansions
was 27 Broadway. Built in 1887, it
was an ornate Victorian with 16
rooms occupied by the Cardin and
Chambers families. It was purchased
in 1918 by Frank Yorkheimer.
Here Stella Yorkhiemer poses
by the massive ornate staircase.
The elaborate interior featured
huge wooden paneled doors and
intricately carved wooden lacework
that can be seen below in the
image of Estelle Gould and her
daughter Jedell. The Yorkheimers
lived here from 1918 until 1959.
(Both courtesy of TPL.)

YORKHEIMER RESIDENCE EXTERIOR. Over the decades, the once opulent home gradually declined in beauty, as did the neighborhood. Once one of Tacoma's finest mansions, it met the wrecking ball in the 1950s to make room for the new high-density 1960s-era Belmont Terrace Apartments. The passing of this mansion and others during this era marked a significant change in the look and feel of the neighborhood. It had changed from a prestigious neighborhood to a neglected and forgotten area comprised mostly of rooming and boarding homes. (Both courtesy of TPL.)

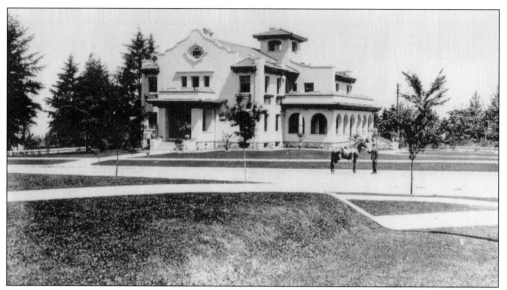

THEN AND NOW. Russell and Babcock Architecture Firm designed this 1905 Spanish mission–style mansion for William F. Sheard. Sheard had business interests in firearms, furs, taxidermy, and Northwest art. The mansion was leased to John Phillip Weyerhaeuser from 1916 to 1923. In 1920, it was chosen as one of the three most beautiful homes in Tacoma. John Buffelen, president of Buffelen Lumber and Manufacturing, purchased the home in 1923 and resided there until his death in 1941. The house was demolished in 1959 to make way for the Vista Palms Apartments (below). (Above courtesy of TPL, below courtesy of TPU.)

STAIRS TO THE PAST. These "stairs-to-nowhere" once led to the 318 North E St. home of Capt. Everett Griggs (page 44), son of Col. Chauncey Griggs (page 41). Captain Griggs led the Washington National Guard, Troop B cavalry exercises in Stadium Bowl's 1910 opening ceremony (page 87). Vice president of St. Paul and Tacoma Lumber, he and his family were active in the Woodbrook Hunt Club, Tacoma Lawn Tennis Club, and the Tacoma Golf and Country Club. (Courtesy of Amberose Longrie.)

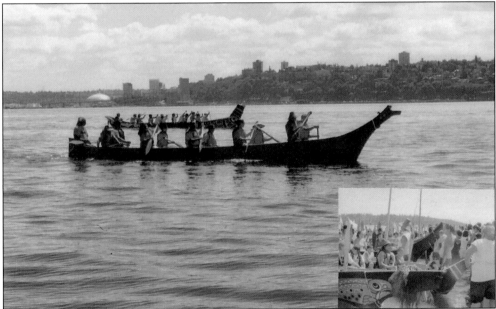

PUYALLUP CANOE JOURNEY. The Puyallup Indian tribe paddles their ke'lo-bit on the Whulge (Puget Sound) *c.* 2000, symbolizing the long journey the tribe has made since the 1873 seven-word telegram announcing the NPRR terminus. Stadium High School and Bowl are in the background, along with the remnant pilings of the old NPRR coal bunkers. The inset image shows pi-yats branches on the canoe, cedar hats, and cedar paddles. (Courtesy of Puyallup Indian tribe.)

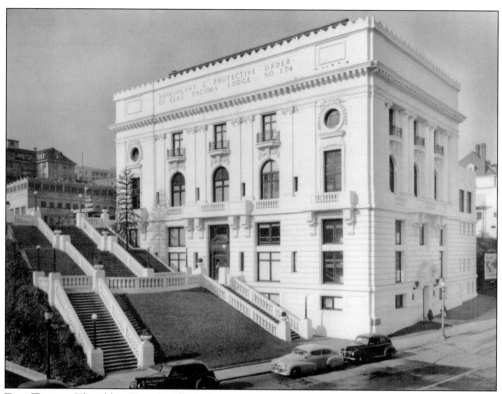

ELKS TEMPLE. The oldest Tacoma Elks lodge was organized in 1890. The Masonic cornerstone ritual for the Elks Temple at 565 Broadway was conducted in 1915. Construction was complete in 1916. It was considered the handsomest Elks club in the nation. Tacoma's "Spanish-stairway" is located next to the Elks Temple. Sold to private investors in 1968, it gradually fell into disrepair. McMenamins purchased the building in 2009 and has plans for extensive renovation. (Courtesy of TPL.)

505 BROADWAY. Once called "Bankers Row," many historically prominent Tacoma families built their mansions here and called it home. Ken Abbott has built upon the historic roots of Bennett Nelson's home built at 505 Broadway in 1889 (pages 32–33) with brand-new luxury condominiums. Abbott recreated the prestigious traditional architecture and spectacular views of this address—bringing its rich history back to the future—for tomorrow's generations to enjoy. (Courtesy of Ken Abbott.)

PRESERVING HISTORY. Gen. James Ashton (right) stands in front of the Ferry Museum in 1935 (now WSHS Research Center) to donate the flag that was presented to Washington National Guard, 24th Cavalry Division, Troop B by Clinton P. Ferry (Duke of Tacoma). Troop B served as honor guard at the 1889 inaugural ceremonies of Elisha P. Ferry, first Washington state governor. General Ashton served as captain of Troop B, the oldest military group in the state. Many Troop B members founded the Tacoma Riding Club, which became the Woodbrook Hunt Club. (Courtesy of TPL.)

PRESERVING EQUESTRIAN LEGACY. Nearly a century to the day after Troop B rode in Stadium Bowl's opening ceremony, WHC members donate over 100 years' worth of local equestrian history to WSHS. Dressed in formal English hunt attire, Haley Parks (AWS 2013); Jean Brooks, WHC master of the fox hounds (MFH); Ed Nolan, WSHS archivist; David Nicandri, WSHS CEO; and Mike Wager (SHS 1962), WHC joint MFH, donate Iris Bryan's (SHS 1925) WHC scrapbook, which covers WHC history since 1892. (Courtesy Rob Karabaich, Old Town Photo.)

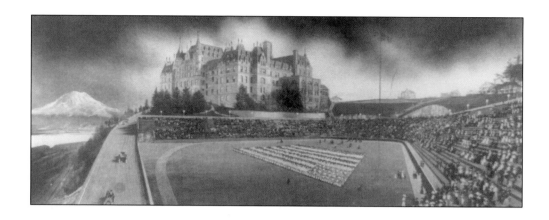

STADIUM BOWL: 1910–2010. Tacoma's Eighth Wonder of the World, Stadium Bowl celebrates its centennial in 2010. Member of the class of 1970 Patti Stephans Lynn heads up the Bowl's centennial celebration, just as she did the Stadium High School's Centennial Celebration in 2006, which happened to coincide with the re-opening of Stadium High School after its $108 million renovation. The dirt and grass field, which was often muddy, has been replaced with the most up-to-date artificial turf. Record-breaking crowds are expected to attend the celebration. (Above courtesy of Tom Stenger, below courtesy of Amberose Longrie.)

REFLECTIONS. A major renovation of Stadium High School was completed in 2006. This also marked the opening of the new auditorium, which included a state-of-the-art theatrical stage, gymnasium, pool, and industrial arts facilities. The old is reflected in the new, linking the past to the future. The re-opening and 2006 re-dedication of Stadium High School marked its centennial anniversary, which was celebrated over three days. (Courtesy of Amberose Longrie.)

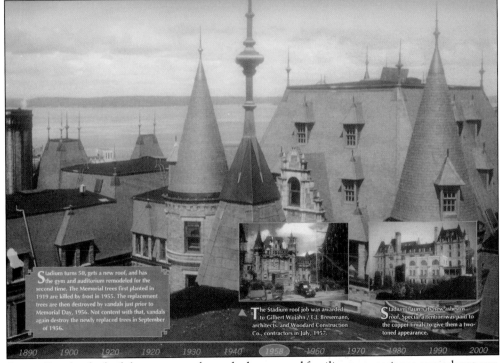

Stadium turns 50, gets a new roof, and has the gym and auditorium remodeled for the second time. The Memorial trees first planted in 1919 are killed by frost in 1955. The replacement trees are then destroyed by vandals just prior to Memorial Day, 1956. Not content with that, vandals again destroy the newly replaced trees in September of 1956.

The Stadium roof job was awarded to Gilbert Wojahn / E.J. Bresemann, architects, and Woodard Construction Co., contractors in July, 1957.

Stadium flaunts its new asbestos roof. Special attention was paid to the copper finials to give them a two-toned appearance.

1890 1900 1920 1920 1930 1940 1958 1960 1970 1980 1990 2000

SPIRES. People who had the courage to leave the known and familiar, to experience new adventures, to dream, to hope, and to create a new destiny are symbolized in the spires reaching to the heavens from the majestic Brown Castle in the very special place of Tacoma's Stadium District. (Courtesy of SHS.)

DISCOVER THOUSANDS OF LOCAL HISTORY BOOKS
FEATURING MILLIONS OF VINTAGE IMAGES

Arcadia Publishing, the leading local history publisher in the United States, is committed to making history accessible and meaningful through publishing books that celebrate and preserve the heritage of America's people and places.

Find more books like this at
www.arcadiapublishing.com

Search for your hometown history, your old stomping grounds, and even your favorite sports team.